MUSEUM MOVEMENT TECHNIQUES

MUSEUM MOVEMENT TECHNIQUES

How to Craft a Moving Museum Experience

Shelley Kruger Weisberg

ALTAMIRA
PRESS

A Division of
ROWMAN & LITTLEFIELD PUBLISHERS, INC.
Lanham • New York • Toronto • Oxford

ALTAMIRA PRESS
A division of Rowman & Littlefield Publishers, Inc.
A wholly owned subsidary of The Rowman & Littlefield Publishing Group, Inc.
4501 Forbes Boulevard, Suite 200
Lanham, MD 20706
www.altamirapress.com

PO Box 317
Oxford
OX2 9RU, UK

British Library Cataloguing in Publication Information Available

Library of Congress Cataloguing-in-Publication Data

Weisberg, Shelley Kruger, 1955ñ
 Museum movement techniques : how to craft a moving museum
experience / Shelley Kruger Weisberg.
 p. cm.
 Includes bibliographical references and index.
 ISBN 0-7591-0825-0 (pbk. : alk. paper)
 1. Museums—Educational aspects. 2. Museum techniques. 3. Movement,
Aesthetics of. 4. Movement, Psychology of. 5. Kinaesthesia. I. Title.
 AM7.W3935 2006
 069'.15—dc22 2005035904

Printed in the United States of America

™
∞ The paper used in this publication meets the minimum requirements of
American National Standard for Information Sciences—Permanence of Paper
for Printed Library Materials, ANSI/NISO Z39.48–1992.

Contents

Preface

PICTURE THIS: Children are stretching their arms on diagonal and molding their bodies to form a curve. Are they in a dance studio learning technique? No, they are in your museum learning your educational objectives with Museum Movement Techniques (MMT).

What are Museum Movement Techniques? They are kinesthetic learning strategies designed to engage and empower children to learn about museum objects.

As a movement therapist and dance and museum educator, I recognize the tremendous potential to use movement as a catalyst to learn in museums. Over the past several years I have researched kinesthetic learning and museum education to formulate Museum Movement Techniques.

Based on the spatial, expressive, and social-cooperative qualities of movement, the techniques provide a framework that enables you to craft experiences to meet your educational objectives. The flexibility of techniques allow for application to art, history, science, and children's museums. Most important, they are user-friendly. They are designed for museum educators with no prior training in kinesthetic learning.

Dismiss from your mind images of docents and children dancing through the galleries. That's not what this approach is about. Museum

Movement Techniques are motion-based learning strategies. The techniques simply use movement as a tool for communication and learning. As a tool for learning, movement broadens the museum audience base to include the kinesthetic learner. As a tool for communication, movement transcends socioeconomic boundaries and provides another entry point into content.

A Personal Path to MMT

I was ushered into the dance studio at the age of five along with a friend. We were there because she was slightly pigeon-toed and I was slightly chubby. Since then, the majority of my life has been spent wearing leotards and tights.

My training as a dance educator and movement therapist provided a perspective of dance not only as a beautiful and demanding discipline for the serious artist but also as a natural form of expression providing great emotional and physical well-being even for the person who doesn't aspire to perform before an audience. A love of museums and teaching movement evolved into my creation of Museum Movement Techniques.

It happened when I was working as a docent and touring a group of third graders. I discovered the magic of using movement to help them understand basic design with abstract art. It wasn't premeditated; it simply was the most natural way for me to help them understand and enjoy art.

Engaging children in artwork through movement was an epiphany for me. The energy and total involvement of the children was better than any verbal dialogue about the art. I needed to fully understand the dynamics of this museum movement experience. It was unacceptable to me for this museum movement process to be viewed simply as an "activity." Much more was going on. The children were involved in the creative process of discovering the art through movement. This creative process facilitated their understanding of art and enabled the children to relate to it. I needed knowledge to substantiate the credibility of this technique. I wanted theories (see chapter 2) and methods to validate the use of movement as an interactive technique to engage children in learn-

ing about museum objects. A new search was on, the search for a graduate program that would allow me the resources to research and develop a conceptual framework and pedagogy for Museum Movement Techniques. I found such a program at Lesley University, where I received my master's degree in education.

Book Summary

Chapter 1 begins with a lively description of children learning about museum objects with Museum Movement Techniques. The process, method, and topic of facilitation are addressed, and feedback from museum educators trained in the techniques is included. Chapter 2 discusses the theories that lay the foundation for MMT principles. Chapter 3 illustrates how Museum Movement Techniques fit into the context of museum education. It also includes a survey on what kind of movement programs currently exist in museum education programming. Chapter 4 traces the evolution of Museum Movement Techniques pedagogy by describing the development of nomenclature, selection criteria, entry points, and educational links culminate in a hierarchical framework. Chapter 5 offers ideas on integrating MMT with museum educational programming, comments from leading museum authorities, and future implications.

I believe Museum Movement Techniques provide a powerful method of engaging the mind, body, and emotional selves of children in the dynamic process of learning and discovery of museum objects. It is my hope that museum educators will embrace this method so children may participate in a truly *moving* museum experience.

A Moving Museum Experience

The ancestor of every action is a thought.

—RALPH WALDO EMERSON

THE GALLERY is silent as the children examine the abstract painting's lines, shapes, and colors. Gradually the painting comes to life as children's arms and legs bend and stretch to portray the different brushstrokes. Concentration on the painting escalates as the children express through movement the different emotional qualities of the painting's colors. Strong direct actions portray the color red, whereas soft languid movements reflect the hues of the faint lemon-lime color. Bodies stretch and twist to simulate the shapes of the brush strokes. Oblivious to anything else, the children are involved with the painting intellectually, emotionally, and physically. What these children are doing is making the painting come alive with Museum Movement Techniques (MMT).

The very idea of moving in a museum has tremendous appeal to children perhaps because moving in a museum seems so contraindicated.

Children's visits to museums necessitate rules but all too often are laden with restrictions. Therefore, it's understandable that children can't fathom the idea of moving in a museum and are excited about the prospect.

Paramount to the success of Museum Movement Techniques is the manner in which movement is used. How exactly does the process unfold? The constructivist nature of Museum Movement Techniques lends itself best to a "demonstration" of the process while explaining it.

Observing the MMT Process

Let's begin by "observing" a museum educator using Museum Movement Techniques, via the following vignette. The educator employing Museum Movement Techniques is the *facilitator*; the child participants in the vignette are referred to by their first initials. Note that the facilitator never instructs children how to move but rather encourages personal movement interpretation prompted by techniques. Museum educational objectives provide a focus, yet the child controls construction of the experience. This ideal is accomplished by matching a museum's educational goals with the techniques that foster that understanding. The strategies are designed to be used in conjunction with current interpretive touring techniques.

Vignette

While sitting with the children in a circle, the facilitator asks, "What do you think is going on in this painting?" The gallery is heavy with silence as the children examine Phillip Evergood's painting *Music* (figure 1.1). Suddenly hands shoot up. D. replies, "I think the people in the back of the workshop and front are making music." J. adds, "They're making loud music."

"What do you see that makes you think they're making loud music?"

J. answers, "All different instruments playing at the same time." The question prompts B. and J. to notice the body attitudes, facial expressions, and dark colors. B. says, "I think they're sad. Lots of people's faces are sad."

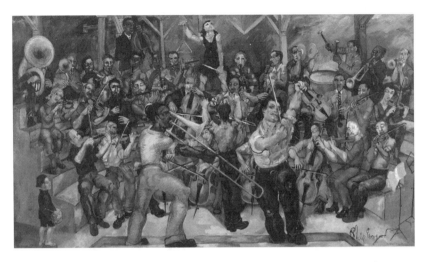

FIGURE 1.1 Philip Evergood (American, 1901–1973) *Music*, 1933–1959, oil on canvas, 72 × 112", Chrysler Museum of Art, Norfolk, VA, Gift of Walter P. Chrysler, Jr. in memory of Jack Forker Chrysler, 80.73

The question, "What else do you notice about the people?" leads to a conversation about the different people portrayed. The facilitator repeats the children's discovery that different instruments and people are working together. The museum educator's goal to discover and create personal meaning for the painting is realized by the children. They begin to personalize the concept of people working together by talking about similar experiences like being part of a soccer team.

At this point the children are invited to paint imaginary glue on their feet and stand an arm's distance from their neighbor. They are instructed not to move from their stationary spot. Invasion of another's personal space is not tolerated. Children who are unable to follow the rule are not allowed to participate should they challenge. Standing in one place encourages a specific type of movement that's grounded and easier to manage.

The movement experience begins as the facilitator encourages children to mold their bodies into shapes the children find in the painting. L. says, "I'm a circle," meaning the cymbal. Everyone mirrors by shaping his or her body to resemble a cymbal. Close examination of the painting leads to discovery of shapes. The children enthusiastically act

out their discoveries. D. contorts his body to form "the stairs." Surprisingly, the children note some shapes the facilitator never noticed. The children greatly enhance their knowledge of the shapes' properties by physically exploring them.

Next the children assume different poses of the musicians. The facilitator takes on the role of the conductor and leads the orchestra with an imaginary baton. Children move in place as if playing their instruments to the conductor's stop and start command. The mood of the music is influenced by the colors and posturing of the musicians and their instruments. Children are challenged to create a movement for the painting based on what they see. L. taps her pretend tambourine, J. strokes the air to move the slide of his imaginary trombone as he hums, "Puussh, puusshh, puusshh." The sequential playing of imaginary instruments creates a movement composition. A melody of sounds and animated bodies fills the galleries. The painting is alive with personal meaning for the children.

Reflection

As the movement part of the experience comes to a close, the children again sit in the circle to reflect on what they discovered about the painting. Excitement from the experience stimulates sharing of ideas. Children's inhibitions are greatly diminished at this point and generally give way to extraordinary dialogue. The facilitator invites the children to articulate why they moved as they did. As they are called on, children approach the painting, pointing to their observations that validate their interpretation. All the children raise their hands to contribute ideas. Participation is unanimous. At times it is necessary to limit comments due to time constraints.

The wide range of both verbal and movement creativity is enhanced by the acceptance of ideas that are relevant to the painting. The children's willingness to develop a verbal and movement narrative for the painting attests to the children's confidence. The facilitator creates an accepting atmosphere assuring children that there is no right or wrong way to interpret as long as they have a reason. The question "Why is there no right or wrong way to interpret the painting?" is answered by D. who says,

FIGURE 1.2 MUSEUM MOVEMENT TECHNIQUES NOMENCLATURE

Mirror (used with realistic or animate museum object)—invites children to duplicate the museum's object with their bodies. Simulation of realistic/living design is considered to be easier and therefore basic. Stationary spatial movement simulation with regard to line and shape requires spatial skills. Facilitates understanding of mathematics.

Alive (used with realistic or animate museum object)—stimulates children to create movements inspired by the lines and shapes of the museum object. Expression of realistic/living design is considered to be easier and therefore more basic. Expressive movement interpretation requires communicative skills. Facilitates development of language arts and science.

Map (used with abstract or inanimate museum object)—finds children reading the different lines and shapes of museum object with their bodies. Simulation of abstract/nonliving design is considered to be more sophisticated therefore more advanced. Stationary spatial movement simulation with regards to line and shape requires spatial skills. Locomotive spatial movement simulation considered more sophisticated. Facilitates understanding of mathematics.

Express (used with abstract or inanimate museum objects)—encourages children to convey the emotional impact of museum object's line and shape. Expression of abstract/nonliving design is considered to be more challenging therefore more advanced. Expressive movement interpretation requires communicative skills. Facilitates development of language arts and sciences.

Composition (used with realistic/animate or abstract/inanimate museum objects)—challenges children to work together to sequence movements portraying spatial concepts (line and shape) and expressive (emotive and descriptive) qualities. The collaborative nature of technique qualifies it to be more sophisticated. Execution requires children to relate to the spatial expressive and social-cooperative elements of museum object. Facilitates understanding of math and sciences, language arts, and social sciences as well as development of cooperative skills.

focus children's wandering attention or to reenergize a lethargic group. The techniques are tremendously effective when one wants to involve children emotionally, physically, and mentally with the museum object or when the museum object shouts kinesthetic involvement. With regard to content, the techniques' entry points allow educators to link with educational objectives.

What Are the Techniques?

MMT entails five techniques based on spatial, expressive, and social-cooperative elements of movement (figure 1.3): Mirror, Alive, Map, Express, and Composition (figure 1.4). They are designed to be used in a hierarchical manner in a variety of museums—art, history, science, and children's—and link to educational objectives determined by national standards of learning (table 1.1). Most important, they are "user-friendly," designed for museum educators with no prior knowledge of kinesthetic learning strategies.

What Are the Steps?

The process begins by providing for the children an overview of what to expect with a Museum Movement Techniques experience. An introduc-

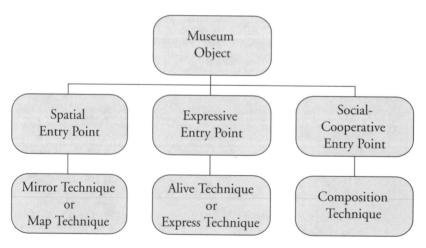

FIGURE 1.3 MMT ENTRY POINTS AND TECHNIQUES

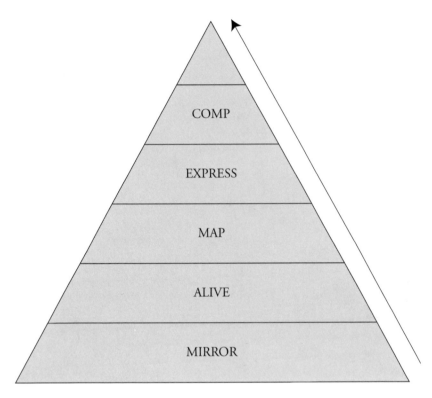

FIGURE 1.4 MMT Hierarchy

tion, a definition of rules, an orientation, and a description of museum education objectives are the steps to successful implementation.

Introduction

"Welcome children. We're so glad you're with us today. Today's an extra special day because we've been given permission to make the museum objects come alive. But in order to do this, there are special rules. We have three rules."

This welcome provides children with structure for the Museum Movement Techniques experience. They learn that they are about to participate in something out of the ordinary, heightening their interest and anticipation. The inclusive structure allows the children to become shareholders in the experience. The phrase "come alive" catches their attention and piques curiosity.

TABLE 1.1 MUSEUM MOVEMENT TECHNIQUES NOMENCLATURE
CONNECTIONS

Technique	Museum Object Selection Criteria	Corresponding Movement	Skills Required	Academic Disciplines Link
Mirror	Realistic or Animate	Simulate	Spatial	Mathematics
Alive	Realistic or Animate	Simulate + Activate	Spatial + Expressive	Mathematics + Language Arts/ Science
Map	Abstract or Inanimate	Simulate	Spatial	Mathematics
Express	Abstract or Inanimate	Simulate + Activate	Spatial + Expressive	Mathematics + Language Arts/ Science
Composition	Realistic or Animate	Simulate + Activate + Cooperate	Spatial + Expressive + Cooperation	Mathematics + Language Arts/ Science + Social Science
	Abstract or Inanimate			

Rules

"The first rule requires you to define your moving space boundary. What's your moving space boundary? Well, that's the space you create by standing in one spot and stretching your arms up and down and all around. Why do you think your moving space boundaries are important in a museum?"

Asking children to think about why it's important to have movement boundaries makes them realize they are in control and responsible for their movements. The facilitator and children discuss why the museum would be upset if the children knocked into another child or an object.

The consequences of invading another child's personal moving space, such as throwing an arm into a neighbor, are very simple. Children who challenge the rule or are unable to demonstrate control will not be allowed to participate. The size of the group allows the facilitator to identify a child who is unwilling to comply. Encroachment on another's personal moving space or body contact is simply not allowed. Should a child exhibit unacceptable behavior, he or she is asked to leave the group and sit with a supervising adult. Presentation of this rule in this manner makes participation a privilege and increases children's willingness to obey.

"The second rule requires you to do something. What does it mean when I raise my hand? Right, it means quiet and today it also means stop. Let's see if we can move our arms all around when I say, '1-2-3 move' and stop when I raise my hand and say, '1-2-3 freeze.' Don't let me fool you."

This rule establishes a control mechanism for the movement facilitator. This technique will freeze the action and bring the children's movement to a halt. Presentation as a game challenges the children to conform. The "1-2-3" alerts children verbally, while the hand up cues them visually. Anytime during the experience, for whatever reason, this technique may be used to stop the action as well as modulate volume control. The importance in maintaining a museum "voice" to encourage concentration is stressed.

"The last and most important rule is to have a good—that's right—a good time. What's going to permit us all to have a good time? You're exactly right. Following the rules."

The facilitator's actual statement that "fun" is included as a rule serves to win the children over. They feel the facilitator is on their side and wants them to enjoy the experience. The children understand the rules and they understand the consequences. On rare occasions a child may choose not to participate, due to religious beliefs, poor self-esteem, and so forth. Allowing such a child to sit off to the side is perfectly acceptable. Conversely, children with physical disabilities should be encouraged to participate to the degree possible.

Orientation

"Remember we said it's a special day because we're going to make the museum objects come alive. Well, you don't like to move, do you? You do? Well, that's great because when we move there is no right or wrong way to move. In addition 2 + 2 always makes what? You're exactly right—4. In addition your answers are either right or wrong. But with interpretive movement, it's what it means to you. It's your own interpretation of the museum object. So there is no right or wrong way to move, as long as your movements thoughtfully relate to the museum object."

Implying that the children don't like to move stimulates the predictable response "Yes, we do too like to move." The facilitator's clarification of movement's not having a right or wrong dimension elevates children's confidence to participate. Children are made to understand that their movements must be linked to the museum object and educational objective.

Layering Museum Education Objectives

"Today we're going to. . . ."

At this point, introduction of the museum educational objective occurs (sample educational goals for art, history, children's, and science museums are presented in chapter 4). The designing of Museum Movement Techniques to enhance learning about museum objects is not limited to the examples cited. The techniques provide a framework, not a recipe. Facilitators have the creative freedom to fashion techniques to meet their educational objectives. Regardless of the type of museum

or museum object, what remains constant is the use of movement as a tool to learn and to express. The inherent qualities of movement are used to interpret the museum object and construct personal meaning.

How to Do the Techniques

Before implementing each technique, the facilitator asks children to carefully observe the museum object (three-dimensional realistic sculptures are most conducive to MMT and thus a logical place to start). Question-and-answer dialogue ensues to stimulate verbal engagement. Working with the MMT hierarchy (figure 1.4), let's begin with the most basic technique, Mirror.

Mirror Technique

The Mirror technique asks children to assume the shape of realistic sculpture (e.g., *Lynched,* depicted in figure 1.5). As the facilitator calls, "One, two, three, show me," children and facilitator strike the sculpture's pose. The children's poses are a frozen moment in time similar to a "snapshot." Assuming a pose is less intimidating than initiation of movement and therefore enlists children's participation. Identification

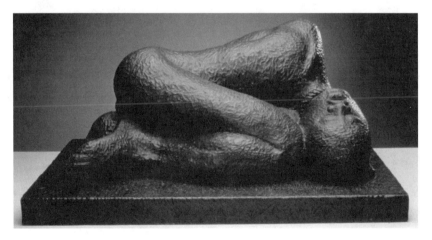

FIGURE 1.5 Seymour Lipton, *Lynched,* 1933, Mahogany, 14 × 24 × 17", 2002.120

with the figure enables children to feel the emotional content of the work. The facilitator duplicates and invites children to experience different poses initiated. Facilitated discussion follows as to why certain poses were created. Spatial placement of the children's body stimulates skills that facilitate understanding of mathematical concepts.

The realistic *Lynched* provides a springboard to the next piece in our example, *Artic Bird* (figure 1.6). It is recommended that the initial technique, Mirror, is used with realistic sculpture, a human form, something all children can relate to. Introduction of an animal form builds on the human experience by including another realistic form.

Alive Technique

The Alive technique prompts children to first Mirror the flowing shape of the bird and next design a movement based on their observations. Visual interpretation of sculpture will dictate expressive quality of movement interpretation. Alive's verbal cue of "one, two, three, activate"

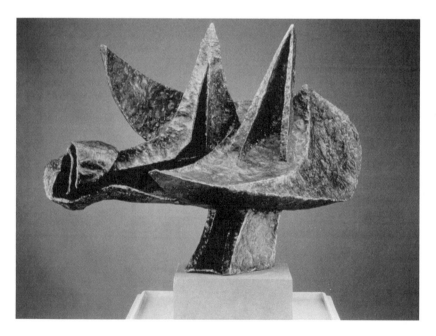

FIGURE 1.6 Seymour Lipton, *Arctic Bird*, 1960, Nickel silver on Monel metal 23½ × 33 × 20", Collection of James and Barbara Palmer

generates different interpretations of how the bird might flap its "wings." The children and facilitator initiate their movement response in unison. The animal form stimulates a narrative, creating a movement dialogue. Soon wings cease to flap as the bird begins to look for worms.

The choice of an animal form sculpture challenges children to relate creatively to a form other than a human figure. This is an integral link in the presentation of works since the children must first relate to the known before they can successfully relate to the abstract. The facilitator asks why certain movements were initiated. Children thoughtfully relate their movement response to visual observations of sculpture. Activation evokes emotional portrayal through movement and ignites descriptive and communicative skills associated with language arts.

The experiences with *Artic Bird* lead to the introduction of a purely abstract work. Children mold their bodies into the abstract shapes of the sculpture *Odyssey* (figure 1.7) with the Map technique.

Map Technique

This sculpture's free-flowing abstract form invites children to trace its lines in the air with their hands, using the Map technique. This space

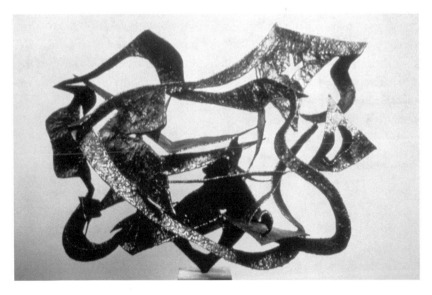

FIGURE 1.7 Seymour Lipton, *Odyssey*, 1957, Bronze on steel, 27 × 38 × 22", 2002.125

drawing provides the kinetic "map" for stationary movements portraying the sculpture's lines. With the cue "One, two, three, show me," the facilitator encourages the children to move one foot along the floor to duplicate the sculpture's free indirect pathways. A more advanced method of Map technique would be to ask the children to use their entire body to map the sculpture as opposed to an isolated body part such as a hand or foot. Imagine a child's head, shoulders, torso, and hips posturing to form the sculpture's indirect pathways. Again the facilitator invites children to experience different movements, validating their visual observations. Such spatial exploration of the sculpture promotes skills that help facilitate understanding of mathematical concepts.

Express Technique

Thorn Mill's (figure 1.8) circular disc and angular plane welcome an interpretation that is set in motion. Children are asked to imagine how the pieces of the sculpture would move independently and as a whole with the Express technique. We begin with Map's verbal cue "one, two, three, show me" as children and facilitator portray the different shapes of the sculpture with the Map technique. The Express technique invites the interpretation to begin with "One, two, three, activate." Children standing in place set the sculpture free as arms swing, heads bob, and hips swivel. The facilitator duplicates their movements and invites others to try different movement interpretations. Again the facilitator asks the child interpreters, "Tell me why you chose this movement?" Activation stimulates expressiveness through a movement narrative, which in turn sparks the language skills of descriptive verbal communication.

Composition Technique

Exodus #1 (figure 1.9) appears as a conglomeration of shapes. No longer can the children identify with a recognizable realistic figure. The Composition technique encourages children to work together and sequentially link the sculpture's lines and shapes through movement. The sculpture is "read" right to left. Initially it would be recommended for each child to create a movement sequence representing lines and shapes (using the Map technique). The facilitator invites children to

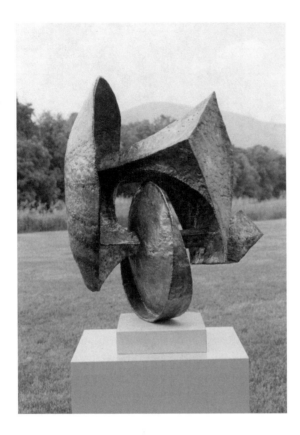

FIGURE 1.8 Seymour Lipton, *Thorn Mill*, 1975, bronze on Monel Metal 3½ × 28 × 19", Collection of James and Barbara Palmer

trace the sculpture's design with their hands and arms. Swooping arms begin the sequence followed by up-and-down actions to portray the jagged lines. Again the facilitator guides children to experience different movement patterns initiated. Validation for their movements based on their observations follows.

Next the facilitator requests the children to work in groups to portray the different shapes of the sculpture (Composition technique). Working together, some children bend their bodies to form the triangular and oval shapes, while others stretch their arms and necks to simulate to the candelabra design. Spatial simulation of design in this way facilitates understanding of mathematical concepts. Verbal activation nurtures descriptive and communicative skills associated with language arts. Group cooperation to simulate design creates a synergy that promotes social-cooperative skills.

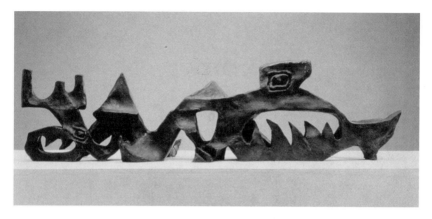

FIGURE 1.9 Seymour Lipton, *Exodous #1*, 1947, Lead construction, 37" long, Reproduced by permission of the estate of Seymour Lipton

Summary: The Course of Action

The MMT process begins with portrayal of realistic human form, progresses to realistic form of an animal, and finally translates to abstract form. Introduction of abstract sculpture begins with an emphasis on simple shapes and then builds to include a composition of several shapes. Activation of the various shapes challenges the children to imagine the kinetic potential in sculpture. Reading a sculpture's lines and shapes gets expressed first by assuming the pose of a human realistic sculpture (Mirror). Next a realistic animal form sculpture is activated (Alive). Abstract sculpture is then experienced by first tracing the spatial path in the air or on the floor with either a hand or foot and followed by using the entire body to portray (Map). Gestural or the partial use of ones body is less intimidating and therefore proceeds postural movement, which involves the entire body. Subsequently the nonrealistic sculpture is activated (Express). The final technique (Composition), asks children to work together to make the sculpture come alive.

The Museum Movement Techniques process allowed children to experience the line, shape, volume, and kinetic energy of museum objects. As the examples indicate in the discussion of the specific how-to's of the techniques, children become more aware of the design components of sculpture by experiencing those elements through movement.

Two Methods of Facilitation

Two methods of facilitation allow you to integrate Museum Movement Techniques with your touring situations and strategies: transitional and extended.

Transitional

You're moving from gallery to gallery, yet you want to involve the child emotionally, mentally, and physically with learning about the museum object. The transitional method allows you to integrate Museum Movement Techniques selectively. It involves asking the children to stretch out their arms horizontally, position themselves so they are not touching anyone, and then paint pretend glue on their feet. To further define children's personal space, the facilitator may ask them to draw an imaginary circle around their glued feet.

The benefits of the transitional or "glue on feet" method are that it

- enables the facilitator to work with many different museum objects in different galleries,
- promotes quick execution of technique, and
- allows the facilitator to apply techniques in smaller galleries.

Extended

The extended method permits you to integrate Museum Movement Techniques with several museum objects in one gallery. A red string is placed on the gallery floor in a circle formation. A gallery 15×25 would accommodate a 9×14 circle for approximately ten to sixteen children, depending on the children's size. Allow two to three feet between the border of the red string circle and the museum object. The diameter of the red string circle needs to be wide enough to accommodate the number of children and their personal moving space.

Children are instructed to stay within the circle. A foot over the line disqualifies participants. The children position themselves inside the circle by standing with heels to the circle's edge facing inward. This formation creates a cohesive group and allows the facilitator to maintain

eye contact with the group. Placement of the facilitator in the circle also strengthens the bond with the children.

To secure proper placement within the circle, children extend their arms horizontally. Each child should be able to stand arms outstretched without touching a neighbor. The facilitator asks the children to bend over and draw an imaginary circle on the floor around their feet, defined as each child's "special spot." The children are asked to stay in their special spot for the majority of the movement session. At the facilitator's discretion, children may be asked to leave their special spot and move within the boundaries of the circle. Allowing children to move along the floor may increase understanding of certain educational objectives. An example of this would be allowing children to comprehend the directionality of a painting's line by placing pretend paint on their feet and duplicating the path of the line.

The benefits of the extended or circle formation method are that it

- allows the movement facilitator to permit movement within the boundary of the circle,
- promotes a cohesive group, and
- enables the facilitator to work with several museum objects in that gallery for an extended amount of time.

Three Variations of Initiation

Museum Movement Techniques are appropriate for three groups of professionals with three different levels of skills.

Museum Educators: The Primary Facilitator

Museum educators' strengths lie in their knowledge of museum policy and educational strategies to engage children to learn about museum objects. The synthesis of Museum Movement Techniques with their current methods of implementation greatly enhances their ability to reach more children.

As likely neophytes to kinesthetic learning, museum educators first strive to become comfortable with the concept of using movement as a tool to learn about museum objects. Movement techniques and museum

object selection criteria are taught in the museum gallery. The final goal is for museum educators to synthesize Museum Movement Techniques with their current interpretative techniques.

Classroom Teachers: The Generalist Facilitator

Classroom teachers also can develop an understanding of how kinesthetic learning strategies embellish educational objectives. Again, the primary objective of MMT workshops for this group is development of comfort with techniques and implementation skills. Understanding of Museum Movement Techniques promotes connectivity between museum visit and classroom learning objectives.

Movement Educators: The Adjunct Facilitator

Professionals trained in movement education are very comfortable using their body as a tool to express and communicate. Their training in engaging children to learn dance or movement concepts qualifies them to use movement with groups of children in other situations. The use of movement in a museum setting, however, requires additional strategies, particularly an understanding of museum policy and museum education philosophy, as well as specific MMT approaches.

A workshop designed for movement educators provides background understanding of important museum policy issues and educational philosophy. Knowledge of museum policies concerning the integrity of the museum objects and visitors is imperative. Equally important is an understanding of methods of interpretation used in museum education. Knowledge of education philosophy inherent to a particular museum is vital.

Of primary importance to Museum Movement Techniques is the spontaneous manner in which the facilitator works with the children. A movement educator who is accustomed to working with children in this fashion is a natural candidate. Nevertheless, care should be taken to steer clear of dance or movement educators who are more oriented toward teaching steps or performing rather than in facilitating the creative process. The facilitator should never teach children how to respond to the museum object but should instead elicit personal movement interpretation.

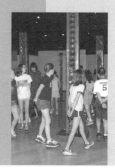

Theoretical Foundation to MMT

To perceive, a beholder must create his own experience.

—JOHN DEWEY

T HE RATIONALE for using movement as an educational tool in museums draws support from substantial research. Significant contributors to theory include Jean Piaget and his views of childhood development, John Dewey and his conception of active learning, and Rudolf Laban and his movement education theories. Evidence of movement theory to education makes a case for movement's application to museum education. Further validation exists with Howard Gardner's theory of multiple intelligences and its specific application to museum education. Mihaly Csikszentmihalyi's elements for optimal learning—emotional, intellectual, and physical involvement—comprise the MMT experience. National arts education research projects such as *Champions of Change: The Impact of the Arts on Learning* (Fiske, 2000)*, Learning and the Art: Crossing Boundaries* (Spitz and Associates, 2000), *Critical Links: Learning in the Arts and Student Academic and Social Development*

(Deasy, 2002), and *Research Priorities for Dance Education: A Report to the Nation* (Bonbright & Faber, 2004) provide additional theoretical underpinning to MMT's principles.

Let's begin with five theories supportive of using movement as a catalyst to learn.

Piaget's Developmental Theory

Jean Piaget's (1896–1980) theory of child development authenticates the importance of movement in developmentally facilitating cognitive processes. Simply put, children learn through experience.

Piaget formulated four stages of cognitive involvement: sensorimotor, preoperational, concrete operation, and formal. The sensorimotor stage takes place between birth and two years. Behavior begins with circular reactions such as thumb sucking. Next follows coordination of vision and the beginning of secondary circular reactions of limbs. Coordination of secondary schemes such as groping for an object precedes the beginning of interiorization of schemes and solutions. Interiorization requires actions to be experienced with thought.

In the preoperational stage, between the ages of two and seven, children can conceptualize as evidenced by language or gesturing. The toddler throwing up his arms and yelling "uppy" illustrates the capacity to link thought, language, and gesturing.

Between the ages of seven and eleven, a child enters the concrete operations stage and acquires such cognitive capacities as seriation, classification, and the ability to think in reverse. A second grader's ability to demonstrate big, bigger, and biggest through movement demonstrates seriation.

In the formal operations stage, between ages eleven and fifteen, children observe regularities in nature, execute "mental" experiments, and mentally combine experiences. Deductive reasoning and logic skills also come into play with the organization of movements.

The crux of Piaget's theories proclaims that active participation nurtures learning, a concept that adds credence to the educational value of movement. Penrose's (1979) interpretation of Piaget proposes "to know something is not merely to be told about it or to see it; it is to act upon

it, to modify it and to transform it" (p. 18). This statement describes as well the premise of MMT.

Piaget's theory of action-intelligence substantiates the use of movement to develop conceptual awareness. Application of activities to enlighten children about museum objects is the goal of using movement to learn in museums. Children better understand the concept of straight and curvy lines if they experience them in the action dimension: movement.

Also following Piaget's theory, the presentation of movement experiences to learn about museum objects must be developmentally appropriate. For example, children's understanding of sequential line size would be introduced between ages seven to eleven during the concrete operational stage. Children would be able to successfully demonstrate through movement the range of the painting's line size from small to large.

Active Learning Theory

The concept of "learning by doing" is echoed by John Dewey (1859–1952), American philosopher and educator. Dewey (1934) believed that "to perceive, a beholder must create his own experience" (p. 54). In *Experience and Education*, Dewey (1949) maintains that all genuine education comes through experience. Application of his educational theories to formal education resulted in America's progressive education movement from the 1930s to 1980s. This holistic child-centered method, referred to as *active learning*, is believed to develop the child's mental, physical, social, and emotional selves.

Education that supports children's personal development and expression and integration of curriculum supports the use of movement theory. The value of movement theory to education, as Dewey envisioned it, has broad applications to both schools and museums. According to Ansbacher (1998), "Dewey's ideas are still current and particularly relevant to the theory and practice of museum education. . . . Creating visitor experiences through interaction with real objects and phenomena continues to be the strength of museums" (p. 47). The key is to create experiences that are age-appropriate and that motivate children to participate. Participation in the formation of the experience and engagement in constructing meaning lays the foundation for children's further learning.

Cole (1998) applauds Ansbacher's application of Dewey's ideas to exhibition development and interpretation. "Key to all Dewey's theories is the nature of the [museum] visitor's experience," she notes. "For an exhibition to have meaning to visitors, the objects and exhibition theme must in some way relate to their personal experience" (p. 78). The use of movement in museum learning provides an interactive personal means for children to understand the museum object through a shared experience. The spontaneous yet directed movement interaction with the museum object nurtures children's desire to learn.

Movement Theory

The principles of movement education theory are the core of learning through movement in museums. Movement education is child-centered, holistic, exploratory learning that substantiates the power of learning through movement. Children's consciousness of their movement sensations develops spatial, temporal, and body part awareness. Moving in a direct or indirect path nurtures spatial awareness. Experimenting with the different qualities of time such as moving fast or slow fosters temporal awareness. Discovering all the different ways to move various body parts enhances body awareness. Right-left discrimination is intensified by moving directionally right-left and by using right-left sides of the body. Movement that requires working in pairs or in groups fosters development of social cooperation skills.

Hungarian-born Rudolf Laban (1879–1958), a movement educator, choreographer, and philosopher, pioneered a movement education theory that increased awareness of the various dimensions in which individuals move. In *The Language of Movement* (1966), Laban shares his belief that motion, emotion, form and content, body and mind, are all inseparably united. He defines *thinking* as a "kineto-dynamic process" and believes that "getting the feel" of movement gives real understanding (p. 124).

Laban's early work focused on dance and theater yet evolved to include all contexts of human movement, including industry, education, psychology, anthropology, ethnology, and sociology.

Laban (1966) believes that "the words of language, giving names to objects and thoughts, conceivably sprang into being in remote times,

from movement impulses which were made audible" (p. 124). The original language was one of total body gesture. Thus speech is believed to have developed from body talk. Laban claims "children and primitive ages, see the world through a bodily perspective, that is through the physical experience" (p. 6).

Movement theory's premise of the body–mind link constitutes the basic principle of using movement for learning in museums. The same spatial, temporal, body awareness, expressive, and social concepts that children obtained through movement education is applied to enhance understanding of museum objects. Movement education advocates child-centered, holistic, exploratory learning and thereby offers support to the use of movement for learning in museums.

Movement Theory's Application to Education in England

Laban's movement theory has been applied to education in England, as described in the Plowden Report (Department of Education and Science, 1967). Considered the benchmark for progressive school reform in England, this report supports Laban's movement theories and practice:

> In the primary school, a harmony was recognized between the general approach to movement and current educational ideas and ideals. With new emphasis on the building up of a child's resources in movement and their extension into many different situations, and with the scope for individual exploration, choice and practice, physical education made a more significant contribution to educational development. (p. 256)

The increasing recognition of the value of expressive movement in England's primary education impacted the change of the "physical exercise lesson" to that of "the movement period." Rather than teaching exercises or techniques, the teacher's goal was to develop each child's potential through movement exploration. "Children will invent different sequencing of movement and will enjoy discovering their bodily powers and capabilities" (p. 257).

Brown and Precious (1968), educators and education lecturers, explore the implications of movement in the *Integrated Day*, an informal, child-centered approach to education that is widespread in England. This philosophy of education is concerned with the physical, mental, and emotional growth of the whole child.

> Children experiment freely with movement, with instruments and dressing up in clothes during the day. Their movement is natural and spontaneous and they also respond to suggestions and react to stimuli. Group movement lessons which are frequently taken are based on and involve the use of body in time, weight and space. The children are never asked to be "giants" or be a "tree" but to feel the qualities of a tree, the strength of it, the forceful roots twisting into the ground, the slow growth and the stretched upward reaching feel of the branches. (pp. 64–65)

The philosophy of the *Integrated Day*, like MMT, recognizes the importance of learning through experience. "Through activity methods the child learns by doing" (p. 38).

Gardner's Theory of Multiple Intelligences

Howard Gardner's theory of multiple intelligences recognizes that individuals learn in a multitude of ways, including bodily/kinesthetic. Multiple intelligence theories challenge the standard view of intelligence, as Gardner (1993) identifies seven "frames" for the discussion of abilities: language, logical-mathematical analysis, spatial representation, musical thinking, the use of the body to solve problems or to make things, an understanding of other individuals, and an understanding of ourselves. In *The Unschooled Mind*, Gardner (1991) argues that children would be better served if academic disciplines were approached and learning was assessed from these various frames. Child-centered teaching would approach a topic from a multiple of entry points, thus nurturing true understanding of a topic.

Gardner's theory provides a framework for the conceptual foundation of using movement to learn. Movement as nonverbal communication probes beyond socioeconomic and educational boundaries allowing

those who might not be verbal or auditory learners to be integrated into the learning process. Specifically, bodily/kinesthetic intelligence serves as the operative tool. The body is the vehicle that experiences "kinesthetic" or physical sensations of concepts designated by the learning process.

Kinesthetic learning allows for understanding concepts of museum objects in a different dimension. For example, the concept of distance as it relates to a painting's perspective can be experienced through movements demonstrating far and near. Children increase their understanding of background and foreground by physically experiencing far and near spatial concepts.

Movement serves as the *experiential* or *hands-on* entry point to learn about museum objects and experience the educational objective. In the case of an art museum, the educator may use movement as an entry point to enhance understanding of basic design. Movement as the experiential medium allows children to become more keenly aware of the basic design of an abstract painting by experiencing its line, shape, color, and rhythm. In the process of moving as these different elements, the children create a design in a different perspective—a dance, in effect, to reflect the painting.

To demonstrate their perception of line, children move in ways that reflect the painting's different qualities. For example, strong, direct, slashing movements depict large, bold splashes of color. These movements contrast with children's indirect, wavy movements that portray curly ribbons of color. The painting's use of color is translated in the amount of energy the children use in executing the movements. Strong colors are illustrated with powerful actions; light colors are portrayed in a soft manner.

"Rhythm" of the painting provides the tempo of the movements. Spacing of the lines creates the rhythm of the painting that is expressed through the rhythm of movement. For example, two short lines together with a space before the next long line translates into movements reflecting a short-short-long rhythm. This activity relates to museum education's general learning objective of enhancing visual understanding and perception.

Quest: Further Application of Gardner's Theories

The loose application of Gardner's theory of multiple intelligences to museum education appears in the form of *Quest:* Questions for

Understanding, Exploring, Seeing, and Thinking, developed by Project MUSE. Project MUSE (Museums Uniting with Schools in Education) is a study at Harvard University specifically focused on art museums. According to Jessica Davis (1996), principal investigator, Project MUSE's goal was to turn the focus from "subject or theme to learner, and to art museum/school connections that are based on *process:* the more general activity of learning itself" (p. 4). It was felt that the majority of school–art museum partnerships focused on content or the relationship between art and the school's theme through subject-based tour (e.g., children studying Egypt would be exposed only to Egyptian artifacts).

The result of Project's MUSE shift from subject to process was the interactive tool of Quest. This interpretive instrument consists of five brightly colored booklets of ten questions, each reflecting the different entry points: narrative, logical/quantitative, foundational, aesthetic, and experiential. Designed to assist in reflection on works of art, the questions nurture the process of learning about art by actively involving the museum visitor with different entry points or perspectives.

The narrative entry point utilizes the story approach to learning. Asking the child, "What is the story that you see in this work of art?" and "How do the colors help to tell this story?" involve children in creating a narrative about what they see in the painting.

The foundational approach explores the philosophical perspective. Questions such as "Take a look at the colors in this work of art. Why do you think these colors were used? Do colors have meaning?" engage children's reflective powers.

The logical/quantitative approach enlists children's analytic and numerical comprehension. Responses to questions such as "Is this work of art older or younger than you? How can you tell?" provide insight into children's ability to reason and knowledge of numerical concepts.

The aesthetic approach invites children to focus on the elements that comprise the work of art. Invitations to "Take turns describing the lines and shapes that you see in this work of art" encourage careful examination and articulation.

The final entry point, experiential, activates participation. Asking children to "Act out what you think might happen next" solicits hands-on and minds-on involvement.

Although designed specifically for art museums, the conceptual foundation of Quest's five entry points has universal appeal to all kinds of museums. As places for individual-centered learning, museums are ideal settings to cater to a variety of learning styles.

The Flow Experience

You study the painting, intently searching for visual cues to validate your thoughts. Your discovery ignites verbal discussion that sparks nonverbal expression through movement. Oblivious to anything else, you are immersed in the painting emotionally, mentally, and physically. You are experiencing *flow.*

In his book *Flow: The Psychology of Optimal Experience,* Mihaly Csikszentmihalyi (1991) defines *flow* as "the state in which people are so involved in an activity that nothing else seems to matter; the experience is so enjoyable that people will do it at great cost, for the sheer sake of doing it" (p. 4).

Certain conditions facilitate the experience of flow. It is necessary that skills are adequate for tasks at hand and feedback is provided. Concentration is so intensely focused on the task that self-consciousness is diminished and sense of time is distorted. The experience of the activity provides the intrinsic reward—that is, a sense of personal accomplishment and increased feeling of self-esteem.

Csikszentmihalyi and Hermanson (1995) explore the flow experience as it pertains to museums in *Intrinsic Motivation in Museums: What Makes Visitors Want to Learn?* According to the authors, "Research indicates that the natural motivation to learn can be rekindled by supportive environments, meaningful activities, by being freed of anxiety, fear, and other negative mental states, and when the challenges of the task meet the person's skills" (p. 35). Learning involves the individual's intellectual, sensory, and emotional selves. Information presented in a manner that is enjoyable and intrinsically rewarding motivates further learning.

Human motivation in relation to learning may be described as either intrinsic or extrinsic. *Extrinsic* motivation finds the individual receiving dividends from a source other than the activity itself. Children exemplify extrinsic motivation when they study in order to get a good grade, earn a prize, or avoid an argument with their parents. On the other hand,

intrinsic motivation finds children exulting in the activity itself. Children's involvement in an activity for the enjoyment of "doing" demonstrates intrinsic motivation. Attention is focused on the task at hand for sheer pleasure and interest in the activity. According to Csikszentmihalyi and Hermanson (1995), "when we are intrinsically motivated to learn, emotions and feelings are involved, as well as thoughts" (p. 59).

Since extrinsic rewards do not exist for museum visitors, the question remains of how to engage museum visitors in an intrinsically motivating experience. A meaningful experience results when the visitor is emotionally and intellectually involved with the exhibit. The use of movement to engage the children intellectually, emotionally, and physically—to create total immersion—crafts such an experience.

Facilitation of the flow experience requires the individual's curiosity with the exhibit to be aroused in order for learning to take place. There must be a link between the exhibit and the visitor's own life. Also necessary is a nonthreatening setting conducive to concentration. Exhibit involvement must be appropriate for the visitor's skills and must offer appropriate challenges and feedback. The conditions that perpetuate the flow experience are likewise the very essence of learning through movement. Movement as a catalyst to learn about museum objects invites children to discover the museum object. Initially they are engaged in open-ended discussion about the object. Questions such as "What's going on?" and "What does this mean to you?" promote linking the object with self. That there is no right or wrong way to interpret the object is conveyed verbally as well as nonverbally through movement and serves to diminish inhibitions while escalating creativity.

Arts Education Research

A plethora of studies underscore the role of the arts in education, including how museum education can enhance children's learning. For example, *Champions of Change* (Fiske, 2000), a study in cooperation with the Arts Education Partnership and the President's Committee on the Arts, examines a variety of arts education programs and explores how children change through their arts experience. This research found the following points to be relevant to education:

- The arts reach students who are not otherwise being reached.
- The arts reach students in ways that they are not otherwise being reached.
- The arts connect students to themselves and each other.
- The arts transform the environment for learning.
- The arts provide new challenges for those students already considered successful.
- The arts connect learning experiences to the world of real work.

Learning and the Arts: Crossing Boundaries (Spitz and Associates, 2000) presents further evidence for the vital role of the arts in learning:

1. The arts teach children to make good judgments about qualitative relationships. Unlike much of curriculum in which correct answers and rules prevail, in the arts, it is judgment rather than rules that prevail.
2. The arts teach children that problems can have more than one solution.
3. The arts celebrate multiple perspectives.
4. The arts teach children that in complex forms of problem solving purposes are seldom fixed but change with circumstance and opportunity.
5. The arts make vivid the fact that neither words in their literal form nor number exhaust what we know. The limits of language do not define the limits of our cognition.
6. The arts teach students that small differences can have large effects. The arts teach students to think through and within a material.
7. The arts help children learn to say what cannot be said.
8. The arts enable us to have experiences we can have from no other source and through such an experience to discover the range and variety of what we are capable of feeling.
9. The arts' position in the school curriculum symbolizes to the young what adults believe is important. (p. 7)

Arts education research such as that cited here supports the integration of movement/dance with education. Links between movement

and academic learning benchmarks exist; however, they should not serve to justify its utilization. It is the intrinsic value of movement as an art form that qualifies its integration with education.

Critical Links: Learning in the Arts and Student Academic and Social Development (Deasy, 2002), a study conducted by the Arts Education Partnership, examines strong studies of the academic and social effects of learning in the arts. The movement/dance learning studies reveal the most consistent indication to be the development of three aspects of creative thinking: fluency, originality, and abstractness. The studies also suggest that movement/dance "may provide a means for developing a range of creative thinking aspects of critical thinking skills" (p. 16).

Research Priorities for Dance Education: A Report to the Nation (Bonbright & Faber, 2004) examines movement/dance education for its intrinsic value as arts education and for its instrumental value as a tool to learn. The report cites "current research, centered on a variety of learning styles and a new understanding of kinesthetic intelligence has opened awareness in the academic community about the effectiveness of creative movement as a tool for learning about other academic subjects" (p. 90).

Summary

The use of movement as a catalyst for learning gains credibility from a wealth of theories. Piaget's childhood development theory substantiates the use of movement to develop conceptual awareness. Dewey's concept of active learning further substantiates movement's application to museum education. Movement education theories reinforce its use for child-centered, holistic, exploratory learning. Gardner's multiple intelligences theory supports the use of movement as an intelligence, within the bodily/kinesthetic domain, to acquire and demonstrate knowledge. Csikszentmihalyi's elements for optimal learning—emotional, intellectual, and physical—are also found in the Museum Movement Techniques experience. Finally, arts education research recognizes the intrinsic benefits of movement as an art form to enhance learning and its instrumental value as a tool to learn. Together these theoretical underpinnings firmly support the use of movement, in general, and Museum Movement Techniques, in particular, as educational tools.

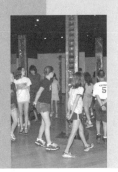

In the Context of Museum Education

What one has not experienced one will never understand in print.

—ISADORA DUNCAN

HOW DOES the use of movement as an interactive technique meet the educational goals of museums? More specifically, how do interactive Museum Movement Techniques integrate with methods of interpretation currently used by museum educators? This chapter addresses these questions by presenting museum education philosophy and interpretive techniques that support the use of movement as a catalyst for learning about museum objects. Results of a survey polling museum educators' use of movement in educational programming are included to provide insight to the degree and manner that museum educators utilize movement.

Museums of the Twenty-first Century

Museums of the twenty-first century are vital, stimulating, visitor-oriented places for learning. The phrases *visitor-oriented* and *places for learning* are of great significance to MMT and warrant further discussion.

Two reports published in the latter part of the twentieth century were monumental in transforming museums for the next century. *Insights: Museums, Visitors, Attitudes, and Expectations. A Focus Group Experiment* (Walsh, 1991) deals with understanding the visitor, while *Excellence and Equality and the Public Dimension of Museums* (Hirzy, 1992) focuses on education. More recently, a report published by the American Association of Museums (AAM, 2002), *Excellence in Practice: Museum Education Standards and Principles,* speaks to the need for diversity of perspectives and multiple entry points into content.

Insights (Walsh, 1991) pertains specifically to art museums. It studies expectations of the museum staff for the visitor as well as the perceptions and attitudes of the visitor. This report offers background on the emerging importance of the visitor experience that is the essence of Museum Movement Techniques.

Reports such as Walsh's redefined the art of interpretation. According to Silverman (1991), "it's the change that results from accepting the overwhelming evidence that . . . visitors do not passively accept messages we send; they bring personal experiences and frameworks to bear in museum" (p. 63). The concept of an educator or docent standing in front of a museum object transmitting information and expecting them to accept their interpretation is no longer the norm, sums up the state of interpretation nicely.

> First, we now see object interpretation, . . . as part of much larger world of current research about knowing and thinking. . . . Second, . . . our programs must acknowledge and grow from the holistic way in which visitors perceive objects. . . . We no longer seek to teach visitors about object reading in a structures linear way. . . . We now see our role as interpreters of material culture as helping our visitors to hone and apply their visual perception skills in museum settings. (Eversmann et al., 1997, p. 137)

Museums as "places for learning" took on new meaning with AAM's *Excellence and Equity* (Hirzy, 1992). This report heralds the equal importance of both excellence and equity in regard to the museum's mission. It proclaims public service of education to a diverse audience to be crit-

ical and to be inclusive of exploration, study, observation, critical thinking, contemplation, and dialogue. The educational purpose is to be embedded in every museum activity and embraced by the entire museum staff from gallery guard, to curator, to trustee. This report provides an educational context for Museum Movement Techniques.

Excellence and Equity (Hirzy, 1992) recognizes the museum's tremendous educational potential and expands on its educational role. The museum serves as a platform for new interpretive methods to engage the visitor in museum object learning. Recognizing the importance of inclusiveness strengthens the need for incorporating interpretive methods that broaden the museum's audience. Museum Movement Techniques supports *Excellence and Equity*'s policy by offering an alternative interpretive method that transcends socioeconomic boundaries and also allows children who may not be auditory or visual learners to be enfranchised in the learning process. Specifically, movement techniques afford museums a unique method of engaging children in a meaningful way to learn.

Support for diversity of perspectives is underscored in AAM's *Excellence in Practice* (Committee on Education 2002). This report cites provision of "multiple levels and points of entry into content, including intellectual, physical, cultural, individual, group, and intergenerational" as a method to promote diversity of perspectives. Museum Movement Techniques serves as another entry point into content. It allows the museum visitor to craft meaning in the physical dimension.

Museum Movement Techniques addresses the current needs of museum education by using movement as a tool in two ways. First, as a tool for learning it expands the museum audience base to include the kinesthetic learner. According to neurokinesiologist Jean Blaydes Madign (2000), "85% of all school age children are kinesthetic learners." Second, movement as a tool for communication provides the museum visitor with another dimension to create meaning and understanding for museum objects.

Museum Education Philosophy

That catatonic stare takes hold as the speaker continues to recite fact, after fact, after fact. It could happen anytime, whether listening to a friend or

attending a lecture. What activates this trancelike state? It's the act of being "talked at" rather than being "talked with." Fortunately, the chances of being "talked at" during a museum visit are greatly reduced thanks to current education philosophy that education is a dialogue, not a monologue. As institutions for informal learning, museums advocate acquisition of knowledge through the use of objects. The very nature of object learning invites inquiry-based discussion and explorative activities.

Museum education philosophy as presented by John Falk and Lynn Dierking (2000) in *Learning from Museums: Visitor Experiences and the Making of Meaning,* George Hein (1998) in *Learning in the Museum,* and Lisa Roberts (1997) in *From Knowledge to Narrative: The Changing Museum* supports interactive techniques that allow visitors to construct meaning in museums.

Learning Model

Falk and Dierking (2000) examine the learning process to identify criteria to apply to the museum learning experience. Analysis of the nature and process of learning with regard to psychology, education, anthropology, neuroscience, and museum research led to their development of the Contextual Model of Learning. This model "posits that all learning is situated within a series of contexts" (p. 10). The three overlapping contexts are *personal, sociocultural,* and *physical,* each integrating and developing over time.

The *personal* context proposes that prior knowledge, appropriate motivation, and emotional, physical, and intellectual actions comprise learning. Creation of a supportive setting conducive to the continuous process of constructing knowledge facilitates this process. According to Falk and Dierking (2000), "learning is not facts and concepts; learning, particularly intrinsically motivated learning, is rich, emotion-laden experience, encompassing much, if not most, of what we consider to be fundamentally human. At its most basic level, learning is about affirming *self*" (p. 21).

The *sociocultural* context of learning maintains that learning is both an individual and group experience. The following recommendations promote the sociocultural context of learning:

1. Experiences are to be designed to promote more than one person sharing the museum experience both socially and physically. Creation of an accepting atmosphere serves to facilitate social interaction.
2. Sensitivity to cultural and socioeconomic diversity in the creation of museum experiences encourages inclusiveness. Utilization of stories, songs, poems, dance, and music that relate in the human context promotes broad appeal to a variety of learners.
3. Training of facilitators in the art of communication and interpretation enhances the learning experience.
4. The designing of postdiscussion topics increases the possibility for social dimension of learning beyond the actual museum visit.

Falk and Dierking (2000) reveal that the "most frequently recalled and persistent aspects relate to the *physical* context—memories of what they saw, what they did, and how they felt about those experiences" (p. 53). *Physical* context pertains to both the museum environment and the visitors' actual bodily experience. The environment in which learning occurs transmits feelings and memories that can be manipulated to enhance learning. Immersion of visitors physically through the senses sets the stage for optimal learning. According to Falk and Dierking, the most compelling learning experiences are all encompassing. All of an individual's sensory channels become engaged in the experience, reducing competing information without reducing complexity. Such all-encompassing experiences provide a sharper focus and a more memorable experience. This is why multichannel/multimodal learning works; it is learning through all the senses (p. 203).

The following factors encourage the physical dimension of learning:

1. Museum environment is designed to direct and motivate learning.
2. Museum experiences are designed to consist of different levels of challenge in order to meet skills and knowledge of visitors.
3. Explanation of goals and rules serves to promote visitors' understanding of experience's expectations.
4. Evaluation to be conducted both pre- and postexperience to provide valuable feedback on effectiveness of museum experiences.

Educational Theory

In *Learning in the Museum,* Hein (1998) applies educational theories of Dewey, Piaget, Vygotsky, and others to museums. Hein maintains that "to pursue an intentional educational role successfully and efficiently, museums need to have a conscious educational policy" (p. 14), the components of which require theories of knowledge, learning, and teaching.

Theories of knowledge and learning embody the essence of museum education whereas theory of teaching addresses the application of theories. Theories of knowledge and learning are presented in a continuum that, combined, create four different educational theories. The knowledge continuum recognizes knowledge to exist outside the learner at one end and to be constructed in the mind of the learner at the opposite end. The continuum of learning theory recognizes learning to be incremental at one end and active at the opposite end. The intersection of these continua creates four quadrants delineating the educational theory domains. Examination of the four educational domains allows for understanding the different experiences museums may provide (see figure 3.1).

Didactic, expository education theory finds information to be learned in a logical sequence with illustrative examples and repetition. Museums following this line of thinking will have sequential and hierarchical exhibits with didactic labels. An example of an education program illustrative of this model might be a content-driven lecture tour of ancient Greek artifacts to integrate with the school's history program of ancient Greece. The tour would begin with the more primitive objects and trace the development of Greek society chronologically through the ancient Greek artifacts. Specific learning objectives as dictated by the school would be incorporated in tour. Children would be expected to describe the ancient civilization of Greece in terms of their art.

Stimulus-response education focuses primarily on the training or method of what is taught. This approach shares with the didactic, expository theory the didactic labels and a sequential arrangement but adds the reinforcement concept. An example might be the stimulus-driven tour of ancient Greek artifacts with computer programs designed to provide feedback on students' knowledge. *Discovery* learning is based on the premise "that learning is an active process, that learners undergo changes

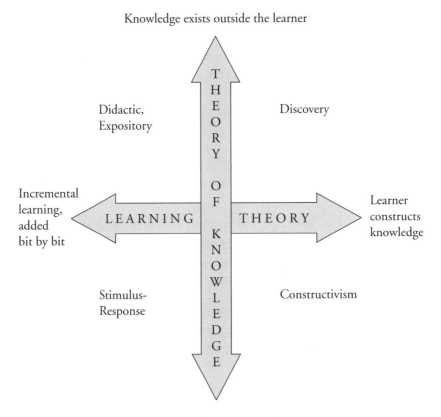

FIGURE 3.1 EDUCATION THEORIES (Hein, 1998, p. 25)

as they learn, that they interact with the material to be learned more fundamentally than only absorbing it, that they somehow change the way their minds work as they learn" (1998, p. 30). Museums embracing this theory will have exhibits that allow for exploration, a wide range of active learning styles, didactic labels that encourage visitors to discover for themselves, and some means to assess their interpretation. Discovery learning as applied to the ancient Greek tour might include children positioning their bodies to form the capitals of the Doric and Ionic Greek columns.

The final domain, *constructivism*, "postulates that learning requires active participation of the learner in both the way that the mind is employed and in the product of the activity, the knowledge that is

acquired" (1998, p. 34). Two components inherent are the acceptance that learning requires active participation and that the conclusions attained by the learner need not conform to an external standard but rather support the constructed efforts of the learner. A constructivist exhibit, like a discovery exhibit, will create opportunities for visitors to construct knowledge. The difference lies in constructivism's validation of visitors' discoveries even if they don't reflect the museum's view. Constructivist exhibits offer several entry points with no specific path, a wide range of active learning modes, and varying points of view. Experiences are designed to allow visitors to connect with museum objects that reflect their life experiences, and school programs encourage students to experiment and formulate their own conclusions. An example of an ancient Greek constructivist tour might have as an objective for children to discover the character of Greek gods by examining sculptures. Close examination of how the artist portrayed the Greek god would provide insight to the essence of that god's character. Children would then move to depict the character of a Greek god. Proud, swaggering movements might portray powerful Zeus, whereas quick, fleeting movements might portray Hermes, the messenger god. Children would validate their movement interpretation based on their visual observations of the sculpture. No two interpretations of the same god may be the same, but each child's construction of interpretation is accepted.

Hein establishes a theoretical educational foundation for museums. He believes "Constructivism provides the most comprehensive and elegant theory to consider how visitors can both use their previous beliefs and knowledge to construct new meanings and how they can actively carry out this process" (1998, p. 154). The following questions need to be considered in crafting a constructivist experience:

- What is done to acknowledge that knowledge is constructed in the mind of the learner?
- How is learning itself made active? What is done to engage the visitor?
- How is the situation designed to make it accessible—physically, socially, and intellectually—to the visitor? (Hein, 1998, p. 156)

Interpretation

The essence of interpretation is communication. Effective interpretation requires connecting the visitor with the museum object. Museum educators have significantly influenced the paradigm shift from focus on the object to the process of looking at it. This shift validated "personal experience as a source of meaning *different from but no less valid than* curatorial knowledge" (Roberts, 1997, p. 70). Emphasis on personal interpretation that creates a narrative about the museum object acknowledges alternative ways of constructing meaning and knowledge. This transfer toward the experiencing of museum objects makes museums "idea-, experience-, and narrative-based institutions" (1997, p. 147).

Visual Thinking Strategies

The Visual Thinking Strategies (VTS) method, developed by noted educator Philip Yenawine and research psychologist Abigail Housen, "is developmentally based, uses facilitated discussion and questioning strategies and taps into rich layers of art, promoting aesthetic growth" (1997, p. 3).

Techniques designed to "exercise the mind" by verbally engaging and nurturing aesthetic development are the cornerstone of VTS. The VTS strategy involves three specific questions. The first question, "What's going on?" stimulates the viewer to look at art and promotes articulation and sharing of ideas. The second question, "What more can you find?" encourages the viewer to look closer, sharpening observation skills. The third question, "What do you see that makes you think?" requires the viewer to validate the thought process by giving visual evidence to support interpretation. A facilitator promotes the process of discovery by literally pointing to observations cited, keeping the viewer focused on the art. The paraphrasing of the viewer's comments confirms observation and interpretation and reinforces reflective thinking skills.

Museum Movement Techniques Interfaced with VTS

The following example illustrates how Museum Movement Techniques can be used with VTS to encourage learning and discovery.

Children learning about lines, shapes and colors are looking at an abstract painting by Hans Hofman, *Into Outer Space* (figure 3.2). In an effort to enlighten children about different lines and shapes, a docent might ask, "What's going on?" First, answers are volunteered verbally. One child yells, "Large slashing red lines." Another chimes, "Orange, blue and yellow squares." At this point the facilitator invites the children to experience the red line with their bodies by tracing the shape in the air. Large slashing diagonal movement permeates the air.

Examination of the different sides of the squares reveals them to be rectangles. The children trace along the floor with their feet the different rectangles. The facilitator verbally accepts the children's answers by repeating them out loud and nonverbally accepts their movement ideas by mirroring their actions. The second question "What more can you find?" prompts the children to look more closely. One child says, "I see a car zooming by buildings." The question "What do you see that makes you think that?" excites answers about the energy and direction of the paintbrush strokes and the color of the paint. Children are invited to express the same emotional content of the color portrayed on canvas through their execution of the different lines and shapes through movement.

Using movement the children experience the different energies of the colors. The background chartreuse makes the light yellow rectangle pop forward, whereas the orange rectangle on the yellow background recedes. The facilitator challenges the children's understanding of the spatial arrangement by having the children place themselves along the floor to show spatial relationships of the shapes. The yellow building stands in the foreground, the orange building positions itself far away, and the red slashing diagonal slices the space in half. Talking about what the children see, and experiencing the different qualities of the shapes, lines, and colors enable the children to develop a greater understanding of the properties of line, shape, and colors. By physically experiencing and interpreting through movement, the children construct their own personal meaning of the art.

With VTS, children are thinking, looking, and talking about the work of art. Thinking through looking develops a wide spectrum of cognitive skills involving visual processing, analytical thinking, verbal reasoning, and testing of hypotheses. Museum Movement Techniques take the dialogue one step further by engaging children nonverbally through movement as well.

FIGURE 3.2 Hans Hofmann (American, 1880–1966), *Into Outer Space*, 1957, Oil on panel, 69½ × 47½", Chrysler Museum of Art, Norfolk, VA, Gift of Walter P. Chrysler, Jr., 71.660, © by 2005 Estate of Hans Hofmann/Artist Rights Society (ARS), New York

Assessment

Assessment of children's understanding is an important part of any learning process and is central to learning through movement as well. Assessment allows both children and teachers to monitor the scope of children's understanding. Instead of tests that consist of right/wrong answers, portfolios and rubrics measure the degree of children's knowledge acquired through movement.

Portfolios include projects, labeled and dated, to show the evolution of knowledge along with students' reflections and self-assessment. A portfolio for "Understanding Basic Design with Museum Movement Techniques" might consist of a series of chronologically dated video sessions recording students' interpretations of the elements of art through movement. Children's development of knowledge is evidenced by the escalation over time of their creative interpretation of line, shape, color, and rhythm. "Understanding Basic Design with Museum Movement Techniques" portfolio exercises are presented in figure 3.3.

Rubrics may be designed specifically to measure comprehension of basic design elements as demonstrated by children's movement performances. Specific criteria define the association of linear art line to linear movement as either *excellent, good, moderate,* or *weak.* The ability to demonstrate multiple examples qualifies as *excellent* understanding, whereas incoherent demonstration illustrates *weak* comprehension. Examples of a rubric to demonstrate knowledge of basic design elements through movement are shown in figure 3.4.

Movement Survey

To better understand the context in which museum educators are currently using movement, I conducted a survey using a series of open-ended questions designed to provide an overview of if and how museums' education programs integrate movement. The survey also provided insight regarding museum educators' interest in movement technique training to enhance their programming (see appendix C).

Four U.S. museums in each of the following four categories were selected: science, history, art, and children's. The following five questions were posed:

FIGURE 3.3 BASIC DESIGN PORTFOLIO EXERCISE

I. Table of Contents

II. Introductory Title Page

 A. Name

 B. Purpose of portfolio—To increase understanding of the elements of art with Museum Movement Techniques. Children increase their understanding of line, color, and shape by experiencing those elements with their bodies.

III. Brief Description of Projects

 A. Children to experience through movement the contrasting elements of line, color, and shape as appears in artwork (children to video movement)

1. Hans Hofman—*Into Outer Space* (Figure 3.2)

Example: Children's movements are linear to correspond with linear lines and shapes in painting. Children's energy in the execution of movement reflects the intensity of color

2. Thomas Evergood—*Music* (Figure 1.1)

Example: Children's movements reflect various shapes observed in painting. Children's execution of movement reflects intensity of colors

 B. Children to create drawing using contrasting elements of line, color, and shape (children to keep drawings in a portfolio)

 C. Children to create movements to reflect their drawing compositions in terms of line, color, and shape (children to video)

 D. Children to make vocabulary list of words to describe line, color, and shape (children to keep in qualitative journal)

 E. Children to analyze art's lines and shapes in terms of geometric angles and figures (children to keep in quantitative journal)

IV. Dates and Labels on All Entries

V. Review Section

 A. Children's reflections

 B. Children's self-assessment

FIGURE 3.4 RUBRIC FOR UNDERSTANDING LINE, SHAPE, AND COLOR WITH MMT

Criteria	Excellent	Good	Moderate	Weak
Expression of line through movement	Ability to demo multiple examples of line through movement	Ability to demo few examples of line through movement	Ability to demo one type of line	Inability to demo
Movement behavior	*Examples:* linear, curving, diagonal	*Examples:* linear, curving	*Example:* Linear	*Example:* Movement does not relate to line
Expression of shapes through movement	Ability to demo multiple examples of shape through movement	Ability to demo few examples of shapes through movement	Ability to demo one type of shape	Inability to demo
Movement behavior	*Examples:* circles, square, rectangle, triangle	*Examples:* circle, square	*Example:* circle	*Example:* Movement does not relate to shape
Expression of color through movement	Ability to demo emotional quality of colors through movement	Ability to demo few examples of color through movement	Ability to demo one type of color through movement	Inability to demo
Movement behavior	*Examples:* gradations of hi/low energy movements reflect hi/low energy colors	*Examples:* hi/low energy movements reflect hi/low energy colors	*Example:* Hi energy movements or low energy movements reflect colors	*Example:* Energy of movement does not relate to color's emotional quality

- What would you interpret movement or dance to mean in the context of museum education?
- Is movement or dance used in any capacity with your museum education programming? If so, how?
- Is movement used as a method of engaging the children to learn about museum objects?
- What would be the level of interest in integrating movement as an interactive touring technique? Great—Mild—Slight.
- Are there ways that your education programming might benefit from utilizing movement techniques with children?

A significant result from this survey indicates that movement is being used in museum education programming. At the most basic level, it serves as a method of nonverbal communication as is evidenced with storytelling techniques. More sophisticated use involves visual skills in reading nonverbal communication of a statue's body language. Moreover, educators acknowledged the power of movement to focus energy and increase audience base.

The challenge is twofold. The first is to make museums aware of the movement technique selection criteria and how to continue to engage children with movement to learn about museum objects. The second is to enlighten museum educators about the different learning attributes of movement techniques.

It appears that all four types of museums regard movement as a spontaneous, free way to move, whereas dance is viewed as a formal arrangement of movement. All museums use movement in some capacity to learn about exhibits and the majority of museums use dance as a cultural thematic tie-in. The ways museums use movement as a method of engaging children to learn about museum objects varies greatly. The majority of educators were open to learning methods to integrate movement as an interactive tour technique. Educators' ideas on ways programming might benefit from movement technique reflect the broad application and flexibility of movement. The first steps in addressing some of these challenges are discussed in the next chapter.

Snapshots of Learning: A Gallery of MMT Experiences

The body says what words cannot.

—MARTHA GRAHAM

MUSEUM MOVEMENT Techniques (MMT) allow children to enter the visual world of museums through motion-based learning. Using movement as an interactive tool to discover museum objects, the MMT facilitator matches the museum's educational goals with the movement techniques that foster that understanding. As described earlier, the facilitator elicits verbal responses from the children using Visual Thinking Strategies (VTS) (Yenawine, 1999). Children share first their verbal responses, then their movement interpretation, in a group setting, justifying their impressions based on their visual observations.

Museum Movement Techniques were designed for various types of museums with respect to educators' goals. All MMT sessions described in this chapter were created for children between the ages of seven and nine years. Developmentally appropriate Museum Movement Techniques catered to the abilities of this age group.

The flexibility of Museum Movement Techniques serves educators in three ways:

- It delivers specific *content,* such as using movement to learn about the parts of a ship.
- It highlights *process,* meaning it uses movement to understand, for example, a painting's shape and line.
- It is *constructivist;* that is, it helps us create meaning for museum objects.

In an effort to explore the potential of movement techniques in a variety of museums, I journeyed to a variety of museums around the United States. I developed techniques to meet the needs of museum educators at the New Orleans Museum of Art, Mariners' Museum, Children's Museum of Richmond, and the Science Museum of Virginia. Let's explore MMT pedagogy more closely by examining a few of the real-life learning experiences that emerged from this hands-on research in art, children's, and science museums.

MMT in Art Museums

Painting at the Courthouse Galleries

A group of homeschoolers visiting the Courthouse Galleries in Portsmouth, Virginia, constitutes a qualitative example of MMT as the learning process unfolds. A series of four hour-long sessions were conducted over four weeks. Each session focused on several pieces of art with multiple learning objectives; to highlight pedagogical development, I will present portions of session 4 here.

As outlined in chapter 1, each session begins with students sitting at least three feet from the museum objects inside a circle created by a red string on the floor in the center of the gallery. The circle is large enough to accommodate the five boys and four girls participating at Courthouse Galleries, allowing the nine children to sit with backs to the string and to stretch their arms horizontally to the side without touching their neighbor. The circle method of facilitation is used to promote a group feeling and to allow for extended exploration of several museum objects in one gallery.

FIGURE 4.1 James Rosenquist (American, b. 1933), *Silver Skies*, 1962, Oil on canvas, 78½ × 198½", Chrysler Museum of Art, Norfolk, VA, Gift of Walter P. Chrysler, Jr., 71.699, Art © James Rosenquist/Licensed by VAGA, New York, NY

The focus of the following excerpt is on the construction of meaning for the art. The children first explore the painting through VTS questioning strategies and then with Museum Movement Techniques.

I present James Rosenquist's *Silver Skies* (figure 4.1) as a puzzle. Children share what they think is happening. G. offers, "The artist is looking through his photo album." D. says, "It looks like someone was cutting up a magazine for a project and the wind blew it all around." J. notes, "Someone was driving a car, washing a car, standing on the cement . . . took off their tires for them to wash and then . . . and someone's arm went into the engine and pulled out a duck." Obviously developing a storyline for the art requires careful examination. Additional observations include "I see wallpaper" and "Silver airplane going down." I gasp at this latter comment, saying, "Wait a moment, L. You said something, and I'm flabbergasted." L. goes to the painting, points, and says, "Right there. It's an airplane, not a car."

"I can't believe this," I exclaim. "I'm looking at my book. Do you know what this painting is called? *Silver Skies.*" To avoid preconceived ideas, titles of artwork are not revealed, so it is noteworthy that L. sees the vehicle as an airplane whereas everyone else views it as a car. Even more surprising is that L. specifically used "silver" in her description, echoing the artist's title.

The children participate in a group effort to express a storyline through movement. They stand heels to the string, facing the center of the circle and extend their arms. They further define their personal space by drawing an imaginary circle on the floor around their feet. All movement occurs in place as defined by imaginary circle around feet. The children and I review the rules structuring the movement discovery of the art.

The painting comes to life as the children assume the pose of the painting's youthful knees and pedal some sort of bike. Movement ideas are shared. The movement storyline unfolds as the group links the images of the painting. The children feel the electricity of the creative process. In resolution of the plot, the children share which part of the painting they most enjoyed reviving: L. exclaims, "I liked being the tricycle, rode up the ramp," and D. finishes that thought with "jumped into the airplane." The group solves the art puzzle together by joining

the separate images into a nonverbal movement narrative, thereby constructing meaning for the art.

Session 4 found the students working as members of a team to produce the final product while the task in prior sessions was the creative development of a storyline by individuals. The collaborative development of the movement storyline signified a higher level of group functioning, with the children exhibiting tremendous confidence in visual observation, interpretation, and social skills.

Reflections

In this example, I applied several principles of movement education to teach about the art: the use of movement to foster understanding of line, shape, and spatial concepts; the expressive use of movement as a means for developing meaning from the art; and the use of group movement to facilitate cooperative skills. This illustration underscores the fact that art and movement embrace the same basic design elements of line and shape. What differs is the medium.

The children in the Courthouse Galleries indicate that certain behaviors appear evident when using movement to learn about art. First, children's interpretation of art through movement causes them to look closer and make finer perceptual observations about the art. Second, the use of movement stimulates them to experience interpretation of the object and provides children another way to interpret other than verbally. Third, movement's social dimension may influence children's construction of both their verbal and movement interpretations.

Painting and Sculpture at the New Orleans Museum of Art

The MMT session designed for the New Orleans Museum of Art (NOMA) has two educational objectives. The first is to involve children with the collection through movement, and the second is to increase awareness of art's basic design elements: line, shape, and color. NOMA's tours encourage children to note movement and rhythm in their collection, and Museum Movement Techniques specifically allow children to experience these elements while learning about basic design.

In an effort to involve children through movement, NOMA's collection is scrutinized for museum objects that contain or suggest movement. The session commences with realistic art interpreted using the Mirror technique. Children examine the art for nonverbal clues to aid in posing. As the children strike the pose of *Sea Spirits* (figure 4.2), they construct meaning for *Sea Spirits* based on visual and physical cues. They try to imagine what types of movements their pose suggests. The action pose leads the children to deduce that the *Sea Spirits*'s dance must be composed of leaping movements based on an angular, asymmetrical stance.

The Alive technique next invites children to portray the expressive quality of *Sea Spirits*. This technique encourages children to invent movements to activate the museum object. For example, application of Alive with the *Sea Spirits* sculpture evokes strong, direct powerful movements.

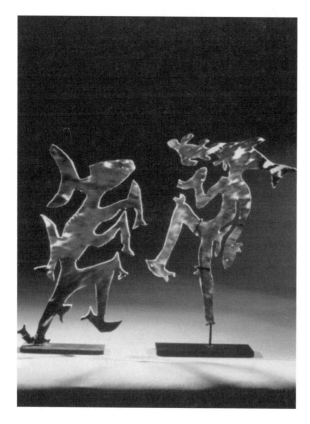

FIGURE 4.2 Unidentified Maker, *Sea Spirits (Akalo Ni Mataka)*, tortoise shell, New Orleans Museum of Art: Bequest of Victor K. Kiam, 77.280

The focus turns to basic design as movement techniques are introduced to increase awareness of line, shape, and color in viewing NOMA sculptures. Using the Alive technique with emphasis on line and shape allows the transition from realistic to abstract art. Visual examination of *Dancer Adjusting Her Stocking* (figure 4.3) facilitates understanding of line and shape in James Lipchitz's abstract sculpture, *Bather*. The choice of these two figurative sculptures of contrasting styles is ideal. The heavy, cubelike quality of the *Bather*'s line suggests a movement qualitatively different from the *Dancer*'s sleek, graceful line. Emphasis on line and shape bridges the departure from realistic to abstract interpretation.

The Map technique continues the focus on line and shape as children now view an abstract work by Sam Francis, *White Line I*. Prior movement experience with realistic art provides the underpinnings for

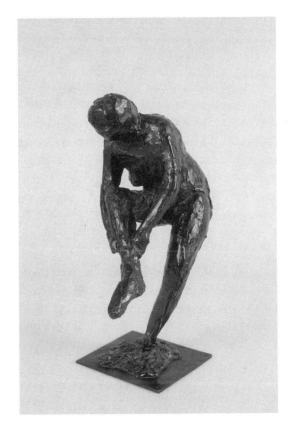

FIGURE 4.3 Edgar Degas, *Dancer Adjusting Her Stocking (Danseuse Mettant Son Bas)*, Dark patina bronze, ca. 1880, New Orleans Museum of Art: Museum purchase through the Ella West Freeman Foundation Matching Fund, 72.21

this transition. Black undulating lines of color pierce red and blue fields. First hands trace the black lines in the air, then in place with one foot moving along the floor. The finale finds children moving in their designated spot to the painting's prescribed black lines and shapes.

Expression of line and shape precedes the movement interpretation of color. The choice of a realistic painting with a primary figure and abstract background aids this process. Romare Bearden's *Jazz Kansas City* depicts musicians playing musical instruments. One brightly clad musician in a bold royal blue suit plays the keyboard. Silhouettes of horn-playing musicians are highlighted by a hot pink and bright green background, dotted with vibrant yellow and red discs. Children assume the musician's pose using the Mirror technique, next the painting comes to life with the Alive technique. The musicians' movements are inspired by how the artist colors and shapes their bodies. Next the children Map the lines and shapes of the painting's background design. The Express technique encourages the interpretation of color to convey the mood of the melody the musicians play. The music comes to life as clenched hands burst open to portray the vibrant red discs, while rising and falling arms reflect the rectangular green slab. This process facilitates transition of the Express technique to a purely abstract painting.

White Line I is revisited to explore the mood of color with an abstract painting. Reds, yellows, and blacks appear in a mosaic conglomeration on one side of the canvas. Dabs of blue and purple dominate the other side. Children associate the colors with objects. Floating movements exemplify the cool blue-purples, and sizzling hot movements express the red-yellows. Enactment of color through the Express technique nurtures a narrative in which red fiery gyrations are extinguished by blue aquatic moves.

Fusion of these movements animates the canvas's spatial design. Group sequencing of line and shape creates a movement narrative using the Composition technique. Abstract art compositions of basic shapes and lines are conducive to this technique.

Reflections

Museum Movement Techniques used at NOMA again initially focus on realistic forms. Gradually the techniques transition to emphasize shape,

line, and color. This paradigm shift promotes inclusion of abstract art and parallels the application of movement techniques with sculpture.

Simulation of the museum objects' poses stimulates construction of meaning for the museum object. Children assuming the body attitude of realistic figurative art can feel the emotion through movement. Children experiencing line, shape, and color through movement increase their awareness of the similarities and differences between types of lines, shapes, and colors reflected in the artwork.

Three issues are apparent at this point. First, the application of certain techniques remains constant with the two mediums, painting and sculpture. Second, the sequential progression from realistic to abstract remains the same for both paintings and sculpture. Finally, the museum education objective dictates use of particular movement techniques.

History Museum

Mariners' Museum

The specific goal of the Mariners' Museum in Newport News, Virginia, is to craft movement techniques that allow children to understand key exhibits. The overall goal is to actively engage children in learning about the museum objects. Traditionally docents share information and engage the children in questioning strategies to learn about explorers, maps, navigation, or parts of a ship. The introduction of Museum Movement Techniques allows children to experience these elements in the physical dimension.

Techniques begin at the basic level of mirroring posture which promotes spatial skills and progresses to emotional portrayal which promotes expressive skills. Gradually as the tour proceeds, more sophisticated movement techniques are layered onto this foundation.

The Mariners' Museum tour embarks by viewing a sculpture of Leif Erickson, the man believed to have led the first voyage to America, in about 1000 A.D. (figure 4.4). The monumental size of the sculpture, as well as its prominent position at the beginning of the first gallery, makes this piece an excellent starting point. The Mirror technique commences with close examination of the statue's body attitude and pose. Demonstrating the stance, the facilitator points out the positioning of the head, chest,

FIGURE 4.4 *Leif Erickson,*
The Mariners' Museum, New-
port News, VA

arms and legs. The technique invites children to assume the larger-than-life posturing of Erickson. The call "One, two, three, show me" rallies children to strike a pose. Children remain frozen as the facilitator points out similarities between the sculpture and the children's poses. Mimicking of stance develops spatial awareness of posturing, which may link to understanding of mathematical concepts. Questions pertaining to how they feel in this position and why they think the body is being held as such ignite speculation and discovery of the individual portrayed.

A few yards away hangs the perfect follow-up to this experience: the painting of Christopher Columbus, knuckles tight on the ship's ropes, swaying as he journeys to America (figure 4.5). With previous experience mirroring a three-dimensional sculpture, the children are comfortable mirroring two-dimensional art. Again close examination of body attitude and posturing is followed by simulation of pose, which leads to

FIGURE 4.5 *Columbus Leaving Palos*, The Mariners' Museum, Newport News, VA

discovery and learning about the individual portrayed. Facilitated discussion folds historical content into the conversation.

Using the Mirror technique, the facilitator promotes involvement by assuming the pose of a ship figurehead (figure 4.6). Mirroring the figure sets the stage for pantomime with the Alive technique. A challenge to guess the character portrayal incites participation. Again reinforcement that there is no right or wrong way to move, as long as it thoughtfully relates to the museum object, nurtures creativity. The Alive technique erects expressive evolvement on a foundation of spatial skill.

The Map technique provides spatial involvement for children with the world map titled *Typvs Orbis Terrarvm* (figure 4.7). Here the children relate to inanimate objects in a spatial context. Children duplicate the spatial arrangement of the different countries and oceans, thereby

FIGURE 4.6 *Commander Morris Figurehead*, The Mariners' Museum, Newport News, VA

enhancing geographic and spatial skills. They thoughtfully arrange themselves along the floor to represent the positions of different countries and oceans. The facilitator serves to censure children's correct spatial placement. Reference to the world map encourages accurate portrayal just as directional focus of the map stimulates awareness of north, south, east, and west.

A spatial task ensues with the facilitator's use of an exhibit map that indicates travel plans to the next exhibit. Children stand oriented as the map indicates and travel north, then west to the next exhibit, the wooden ship. As children step onto the ship's deck, the Map technique now leads the children to physically experience directional commands on a ship. Commands of "aft," "bridge," and "about right" find the shipmates scrambling to obey.

Up to this point, participants have been engaged at a very concrete and basic level. Mirror engages children quantitatively in the spatial portrayal of the figure, whereas Alive initiates expressive portrayal of the fig-

FIGURE 4.7 *Ortellius World Map*, The Mariners' Museum, Newport News, VA

ure. Both Mirror and Map techniques involve the children in the precise duplication of either an animate figure (Erickson) or an inanimate form (country).

The next technique, Express, challenges children to be involved creatively with an inanimate object. Positioning their body (as in the Map technique) to simulate the ship's bell or the propeller invokes creativity. Express technique (figure 4.8) asks children to create the movement inspired by an inanimate object. The expressive quality of movement created is descriptive. No two bells or propellers will move the same; therefore, explanation that there is no right or wrong way to move as long as it thoughtfully relates to the museum object is paramount in diminishing children's inhibitions. Participation by the facilitator serves to increase visitor confidence to take part. Assuming the shape of the ship's propeller, the facilitator's torso twists to create a powerful spinning movement. The facilitator then asks, "How would your bell or propeller move?" This technique stimulates creativity to complement the spatial

FIGURE 4.8 *Propeller—USS South Dakota*, The Mariners' Museum, Newport News, VA

simulation. For this reason, Express sequentially follows the Mirror, Alive, and Map techniques.

Composition technique (figure 4.9) pushes participation a step further. The two exhibits, flight landing pad and submarine interior, are the perfect vehicles challenging children to design a movement sequence for the exhibit setting. Control of children's movement experience is

FIGURE 4.9 *Flight Deck from Defending the Seas* exhibit, The Mariners' Museum, Newport News, VA

achieved by stating guidelines including definition of acceptable behavior while executing the movement sequence. In this case the facilitator establishes specifics of the flight plan in advance and warns that variance will result in "court-martial," or dismissal from the activity. Once landed on the carrier's deck a spatial feat, children work collaboratively to design movement sequences to the submarine. Transformation into a navy Seal allows the children to submerge into the water to board the submarine. Execution of this technique builds on expressive foundations to add creativity supplemented with social cooperation. The success of the experience is dependent on social cooperation.

Application of Composition (figure 4.10) to the August F. Crabtree Collection enlists children in the group creation of a ship. Explanation of the ship's parts precedes children using their bodies to jointly form the model. The facilitator initiates this activity by bending his body to illustrate the various parts of the ship. First one child molds his or her body as the stern, then another as the bow. The ship stands complete as several volunteer to be the ship's multiple sails. The facilitator inquires,

FIGURE 4.10 *Venetian Galleas*, ca., by Crabtree, The Mariners' Museum, Newport News, VA

"What type of boat?" and "What type of weather conditions prevail?" to stimulate a story. As the human ship begins to set sail, a movement and verbal narrative develop. Open jackets take the form of sails to catch the powerful wind as the ship bobs up and down in rough, dark, stormy waters. Ship construction requires spatial awareness and promotes understanding of concepts associated with math whereas creation of a narrative complements linguistic skills. Most importantly is the synergy and social cooperation of working together to produce a finished product.

Reflections

To begin the session at the history museum, it was necessary to identify a key figural exhibit to employ the Mirror technique. Next was the identification of all exhibits illustrating designated educational objectives.

Appropriate movement techniques were then matched to meet educators' goals for key exhibits.

To nurture the educational objective of directional awareness, a spatial movement task was integrated with the Map technique by asking children to move in directions commonly used with maps—north, south, east, and west. As the group became more comfortable with the concept of moving with realistic exhibits, creative movement was integrated with inanimate objects with the Map and Express techniques. The addition of creative movement to an inanimate object is a precursor to more complex movement interpretation. Social cooperation is introduced next with Composition. Each technique builds on the last and fortifies the successful experience of the next.

The use of key vocabulary sets the stage for children's movement experience; used with movement techniques, it triggers imagination. For example, "court martial" or "navy Seals" ignited the children's imagination and placed them into the museum exhibit.

Due to the constraints of a museum exhibit's arrangement, it may not always be possible to follow a strictly prescribed movement technique sequence. What truly matters is the presentation of techniques first with realistic animate forms and then proceeding to inanimate objects. Similarly, a technique requiring social cooperation is introduced after experiencing more basic techniques.

Children's Museums

Children's museums are the quintessential setting for movement techniques. Designed specifically for children, these museums promote interactive experiences, which stimulate learning through discovery. Because children's museums use lots of different ways to involve children, Museum Movement Techniques serves as an additional vehicle for discovery.

Children's Museum of Richmond

The goal at the Children's Museum of Richmond, Virginia, is to design movement techniques to involve children in learning about both themselves and the exhibits. To begin, the Mirror technique challenges

children to position their bodies to simulate the large humanlike sculptures that embellish the lobby (figure 4.11). Children strike a pose to imitate sculptures of a child holding a balloon and riding a bike.

Images that children might enjoy copying meet the specifications of Alive (figure 4.12). They need to imagine the potential enjoyment that portrayals of certain images provide. Mastery of spatial skills with Mirror prepares the students to mold themselves into bees or crabs.

FIGURE 4.11 *Sculpture*, Courtesy of Children's Museum of Richmond, Richmond, VA

"One, two, three, show me" prompts students to assume the object's appearance. The command "Move, two, three" sparks the object to life. Initial introduction of personification facilitates mirroring of objects or animals. Students delight at buzzing like bees and scurrying like crabs. Such expressive portrayal attributes to linguistic skills.

Next the children are asked to visually explore lines and shapes on the ceiling, floor, and walls. Introduction of the Map technique enables children to physically experience the properties of the various lines and shapes. The lobby's architectural appointments provide the perfect visual stimulation for understanding these ideas. A call of "one, two, three, show me" prompts children to mold their bodies into the most basic form, a line. A curved line and a straight line are discovered in the ceiling lighting fixtures. The children mimic the inanimate lines and shapes with their bodies. Next directional slanting, horizontal and vertical lines are experienced. This prepares children to form triangles, squares, circles and

FIGURE 4.12 *Mobil*, Courtesy Children's Museum of Richmond, Richmond, VA

ovals represented on the Contributor's Board and facilitate understanding of geometrical shapes.

Machines that move fascinate children. Express (figure 4.13) gives children permission to think and move as a machine. Exhibits with displays of everyday household items provide a treasure house where they can become human washing machines, fans, mixers, drills, and bikes. They position themselves as the blades of the fan, standing legs together with arms extended with the Map technique. Next, using the Express technique, they twirl in place. Slow turns reflect the fan's low speed, whereas fast pirouettes portray a high speed. Positioning the body as a blade utilizes spatial skills. Temporal movement of the blade is descriptive and nurtures expressive skills.

Composition technique stimulates children to work together to emulate an exhibit.

Execution of the task requires cooperation. An example of an appropriate exhibit may contain building materials such as large Lego blocks, which the children use to create simple shapes that they can then form with their bodies. For example, working in pairs, children face one another, extend arms forward to connect hands, and create a human bridge. A narrative develops as the facilitator asks, "What type of bridge are you?" The answer "old" prompts descending movements depicting a falling bridge. This technique initially involves children in the mirroring of form, which requires spatial skills. Cooperative skills are necessary to execute the movement task. The injection of a storyline about the bridge provides the opportunity for expressive movements. The cooperative skills necessary for this technique make Composition more sophisticated than previous techniques.

Application of Composition to a cooking exhibit finds children morphing into the ingredients of a soup. One child stands perched on a chair as he slowly stirs an imaginary caldron. Another calls out the recipe as children assume the roles of the different ingredients. A dozen dancing carrots, a couple of spinning celery stalks, several rolling potatoes, and a heavy dose of pepper complete the culinary creation. Spontaneous sneezes from the chef, in response to the pepper, punctuate the finale. Careful analysis of measurements prompts childrens' awareness of size and number, two spatial concepts. Creation of the

FIGURE 4.13 *Machine Exhibit*, Children's Museum of Richmond, Richmond, VA

recipe sets the stage for development of a verbal narrative that enhances vocabulary and composition skills.

Reflections

Exhibits need to be examined for their movement learning potential. At the Children's Museum of Richmond, application of movement techniques begins with Mirror to a realistic or animate form—a sculpture of a child. This is followed by activating a realistic or animate form—a crab. Next Map technique is applied to the most basic of all inanimate forms—a line—by Mapping the image of a tubelike lighting fixture. Experiencing a line prepares children to form more complicated shapes—triangles, rectangles—and prepares them to imitate an inanimate object—Fan. With Express children are encouraged to analyze how a fan works and then apply those movement dynamics to their own bodies. Composition provides the culmination to the session by layering social-cooperation onto a foundation of spatial and expressive skills.

Science Museum

Science Museum of Virginia

Movement techniques to facilitate the understanding of energy, force, and motion are the objective of MMT at the Science Museum of Virginia. Traditionally children may discover concepts through a docent-led experiment. Museum Movement Techniques actively engages children as part of the experiment or discovery process. Each movement technique possesses spatial, expressive, and social-cooperative dimensions.

The session begins with Mirror and an introduction to Mr. Bones, a human skeleton. The facilitator challenges the children to assume the stance of Mr. Bones. Next they explore the way the different parts of the human body move with the *Bones in Motion* exhibit (figure 4.14). The children study the exhibit, which consists of a skeletal system with levers attached so that children may activate the joints. They are asked how they think that joint would move. As children experiment with different ways their joints move, they are asked to think of activities that require that particular movement. The children are encouraged to move the *Bones in*

FIGURE 4.14 *Bones in Motion* exhibit, Courtesy Science Museum of Virginia

Motion levers to better understand the range of motion. The names of the different joints are revealed as movements are performed. The Alive technique activates arms rotating in a circular pattern to reveal the shoulder joint to be a ball socket joint. Children demonstrate a softball pitch wind-up to illustrate use of the shoulder joint. The wrist elicits piano playing movements provided by the structure of a swivel joint. The hinge joint of the elbow activates to perform punching movements used in boxing while the saddle joint of the ankle activates to perform movements used in skiing. All ideas on what sports or activities are performed with the specific joint come from the children.

Children are asked to imitate the motion of a swinging pendulum with the Map technique. Children's bodies sway back and forth to the

rhythm of the pendulum. The quantitative aspect is the spatial dupli-
cation of the pendulum's movement path. Express technique prompts
the descriptive manner in which the pendulum is portrayed such as fast
or slow. Children are challenged to speculate how different amounts of
energy affect motion of pendulum.

Map and Express are also applied to a lesson around Newton's three
laws of motion. Facilitated discussion of angles invites children to contort
bodies to form angles of varying degrees. Children experience with Map
the concept of incline as demonstrated in the *Race Track* exhibit. Children
position their bodies directionally to simulate the exhibit's incline. Next
children imagine rolling on those different inclines. Express technique
takes this one step further by allowing children to physically experience
imagined movements. An example would be children experiencing
Newton's Second Law (Force = Mass × Acceleration) by having one child
gently push another child wearing roller blades on a smooth flat surface.
Children correlate the child gliding on the roller blades with the *Race
Track* exhibit (figure 4.15). Specifically, *Race Track #3* is identified as

FIGURE 4.15 *Race Tracks* exhibit, Courtesy Science Museum of Virginia

duplicating the *Race Track* exhibit, which provides three different inclines for a ball to travel along. They hypothesize that doing the same roller blade maneuver on an incline similar to *Race Track #1* would greatly accelerate the speed of the child on roller blades. Map technique is used to facilitate understanding of variance in spatial orientation, whereas Express is used to facilitate understanding of variance in energy.

Knowledge of the planet's schema in the solar system is enhanced with Composition. Explanation of the different planet revolutions and rotations is presented followed by children's enactment. Children volunteer to assume the positions of the different planets as they participate in a solar ballet. Cooperation among the children is critical to completing the movement task. The sun takes its place first followed by the sequential placement of the planets. Activation of the solar system is limited to the earth, moon, and sun due to space restrictions. The sun stands tall at the center of the universe radiating energy by flicking of hands. The Earth coordinates its revolution with the moon as it rotates around the sun. The process of demonstration stimulates much discussion about how to best duplicate the movement patterns of the Earth and moon around the sun. Composition calls on children to utilize spatial, expressive, and social cooperation skills.

Reflections

The order of the session remains the same beginning with Mirror and flowing to Alive, Map, and Express. Introduction of a technique that requires social cooperation such as Composition again follows initial techniques of spatial duplication and expression. A critical factor in making Composition successful depended on the experience of the different parts of the solar system first. Presentation of Composition was actually broken down by using Map first, meaning the children experienced through movement the different parts of the Earth and moon interactions before integrating with the sun. Express injected the energy associated with rotation and revolutions.

The goal of the session was to enhance children's understanding of energy, force, and motion as it relates to museum exhibits. Experiencing the exhibit's concepts of energy, force, and motion enables children to understand by doing.

Summary

Three elements of movement facilitate understanding of museum objects: spatial, expressive, and social-cooperative. These in turn translate into entry points into museum object content that allow children to create meaning for museum objects in a different dimension—a motion-based learning dimension. In order to diminish inhibitions, entry points should begin at the most basic level with spatial simulation, and then proceed to expressive and cooperative engagement.

Identification of museum object selection criteria reveals that two entry points—spatial and expressive—have applications to two different types of museum objects—realistic or animate and abstract or inanimate. This calls for the differentiation between applications of spatial to the different types of museum objects. Likewise, there exists the need to differentiate between applications of expressive to different types of museum objects. Hence the creation of four techniques that illustrate spatial and expressive issues. Mirror and Map both deal with spatial simulation to two different types of museum objects; Alive and Express both deal with expressiveness to two different types of museum objects.

The examples in this chapter illustrate the Museum Movement Technique hierarchy. Movement techniques that engage children in spatial stimulation of realistic or animate museum objects begin the process with Mirror. Next the expressive dimension with realistic or inanimate museum objects is explored with Alive. Exposing children to Mirror and Alive increases their comfort level to experience spatial simulation of abstract or inanimate museum objects. Using abstract or inanimate museum objects once again one begins with the spatial simulation of Map, followed by the expressive dimension of Express. The progression of techniques culminates with the addition of social-cooperative skills with Composition.

The five movement techniques—Mirror, Alive, Map, Express, and Composition—comprising this hierarchy allow educators to systematically integrate Museum Movement Techniques. The three entry points allow educators to realize potential linking to understanding educational objectives (see appendix D).

Moving Forward: Integrating MMT into Museum Education

The body is an instrument, the mind its function,
the witness and reward of its operation.

—GEORGE SANTAYANA

T HE PREVIOUS chapter provided examples of research that underscores the pedagogical value of Museum Movement Techniques (MMT). This chapter will further illustrate the integration of MMT into educational programming from two perspectives: those of John Welch, former director of education and programming at the Chrysler Museum of Art in Norfolk, Virginia, presently with the Metropolitan Museum of Art; and participants at the Victoria & Albert's Theatre Museum in London.

The Chrysler Museum of Art

The development of Museum Movement Techniques began in 1999 at the Chrysler Museum of Art, according to John Welch, at the time director of education and public programs:

Children come to museum educators from all socioeconomic backgrounds, often at different levels of academic preparedness, though grouped in the same grade or class level. Museum educators must devise intellectual strategies that will provide points of access for understanding art, and the concepts or ideas it embodies, in a relatively short period of time (e.g., a single museum visit) and from the perspective of varying types of learners.

The increasing role of state and national standards of learning (SOLs) also present an enhanced challenge to museum educators. Public school field trips to museums must be closely correlated with anticipated SOL curriculum and testing to justify the time away from the classroom by school principals. For many educators, both in and out of the classroom setting, "teaching to test" is viewed as antithetical to "teaching creative thinking."

Today's museum educator must reconcile and satisfy the dictates of SOLs, and the reality of varying learning styles and levels within the museum context, while providing children with meaningful ways to engage and appreciate art.

With regard to the value, if any, of employing a variety of interpretive techniques, Welch believes:

Approaching museum education with a variety of interpretive techniques is essential. Programs, tours, and other educational resources within museums that incorporate kinesthetic approaches to art and learning are very successful. In today's museum, few if any docents would fail to use questioning strategies and other interactive techniques to facilitate engagement with art. This is necessary because it allows audiences to experience art through multiple senses and with learning techniques that are comfortable, fun, and engaging to varying styles of learning.

We know that people have different comfort zones as learners. Some people are very comfortable with abstract thought; others are very literal. Similarly, some people learn best through movement and application rather than theory or concept. Museum educators are charged with providing access to object content on all these levels for the public at large.

Museum Movement Techniques allow children to engage art qualitatively, quantitatively, and through social cooperation. The expressive nature of movement helps children to better understand and identify with these aspects of art, and more broadly, with language arts and the social sciences. The spatial qualities of movement help children to begin to identify mathematical or formal aspects of art in a way that is natural and fun. Through cooperation as a group engaged in seeking ways to individually interpret art and benefit from dialogue, Movement Techniques foster an understanding in children about both cooperation and creativity.

When asked how the education department integrates Museum Movement Techniques into their programming, Welch noted:

> We incorporate these techniques into our educational content for Tickle My Ears, a monthly program to help pre-K children (toddlers) engage works of art. Movement Techniques also work very well with our Saplings program (K–2 students). Here, students and their parents work together to learn questioning strategies that can be employed to heightened cognitive development in cultural settings. This is particularly important where students are identified as "at risk." Movement Techniques intensify the level of engagement between parent and child and help both to naturally participate in the process of interpretation. Because Movement Techniques cut across social, economic and language barriers, they are perfect for programs such as our ESL tours [English as a Second Language], which usually focus on college age populations. Museum Movement Techniques help people to create an expressive language with their bodies to reflect a very personal interpretation of the picture or sculpture they are seeing. The results are always phenomenal.

The Victoria & Albert's Theatre Museum

Director Geoffrey Marsh's question, "Is it possible to define a form of interpretation specific to exhibiting the performing arts, and if so what are the implications?" prompted a Museum Movement Techniques workshop at the Victoria & Albert's Theatre Museum in London.

Eighteen museum professionals from all areas of the museum (curators, educators, design, support staff, etc.) met for four days to explore, imagine, create, and discuss. What follows is my workshop summary along with excerpts from participants.

Presentation of movement as an interpretive tool for museum objects initially was met with the following concerns:

- Would require gallery staffing which was unaffordable
- "Only for children/education," not adults
- "English attitudes" to live interaction were different from North America
- Lack of museum experience and/or institutional confidence
- Strength of 'history art' interpretation, which dominates the V & A
- Challenges of creativity, imagination, language
- Space with regard to health and safety

A facilitated dialogue regarding the Theatre Museum's destiny generated discussion on the museum's uniqueness. It was agreed that the creative quality of theatre, dance, art, and opera deserves an imaginative, creative museum experience. The question posed was "What would create a more creative experience?" Endorse everyone's creativity, allow visitors to have an opinion, stimulate people's emotions, explore creativity through the museum object, and friendly environment were all cited as critical to the museum experience. The issue was how to craft such an experience.

Museum Movement Techniques workshop held with groups of five professionals over the next two days allowed participants to experience the process of making personal meaning for museum objects. Participants were asked to take off their "professional hats" and to partake in the experience as a novice. Curators, management, and educators left their "hats" at the door and participated in the discovery of museum objects first with Visual Thinking Strategies (VTS) and then with Museum Movement Techniques.

Techniques of engagement were demonstrated along with an analysis of skills and educational linking. Participants discovered that visual exploration of the museum object, followed by movement inter-

pretation truly generated personal meaning for the museum object. Interestingly, most participants discovered the curatorial knowledge they desired after this engagement was quite different than information displayed on the labels.

Participants then designed their own Museum Movement Techniques experience for the museum object. While designing the experience participants were also asked to consider how auditory and visual cues may enhance the movement experience of the museum object or influence the redesign of the exhibit. The entire process was driven by creating personal meaning and experiencing the museum object emotionally, mentally, and physically. The results were amazing.

The dynamics of each group produced similar but creatively different results. Both exhibited empathy and personal involvement with the museum object. It was as if they had a personal relationship with the object. The difference was the creative path each group personified the object.

The final day of the workshop, each group presented an overview of their Museum Movement Techniques experience. Some groups summarized their experience verbally; others chose to demonstrate Museum Movement Techniques they designed. Demonstrations ranged from one group making the musical score come alive with movement and sound to another group's development of a verbal and movement narrative.

Issues such as facilitation of experience without an interpreter generated open-ended labeling questions to guide the discovery of museum object. It was recommended that labeling resemble theater posters or casting call sheets and touring guides resemble playbills. Ideas to nurture experiencing of museum objects included placing footprints on the floor to simulate movement (i.e., staging), images to suggest movement of actor or dancer, and mirrors or videotaping to record visitor response.

The issue of personalizing the visitor experience revealed suggestions of visitors assuming the identity of theater attendee or performer. Personal feedback was realized with the suggestion of photo video booths to visually record visitor's response and comment books to post verbal interpretations.

With regard to exhibit design that encourages engagement of visitors, participants suggested to have open exhibit areas versus closed display cases. They also recommended displaying fewer objects to encourage more extensive engagement.

The general consensus was the Theatre Museum must implement MMT into its visitor programming. Indeed, many participants felt that "the successful delivery of such techniques, as part of the visitors experience, would establish the museum as one of the leading educational resources in the UK in its sector."

What remains to be seen is how the Theatre Museum will harness the power of Museum Movement Techniques. Primary issues to be addressed include which objects to use, how to creatively structure visitor engagement, the need for an "introductory" area to explain the type of interpretation, development of themes to connect and to facilitate discovery of objects, space, and design of galleries to encourage engagement, and dissemination of curatorial knowledge to complement object and experience.

MMT Moving Forward

How does Museum Movement Techniques keep pace with museums of the twenty-first century?

Silverman and O'Neill (2004) recognize that museums of the future need "to develop new means of expression and reach new audiences" (p. 43). They go on to say that this "requires an openness to experimentation and risk taking. The personal and institutional commitment to trying new ideas, innovative approaches, and seemingly risky ventures is as important as the canonization of best practices."

Museum Movement Techniques speaks to these needs by providing museum educators with a framework to implement innovative programming. At the same time, it provides visitors with a unique means of expression and allows educators to reach new audiences.

Reaction from Leading Authorities

The American Association of Museums (2002) endorses diversity of perspectives and process-oriented museum visits, a view that beckons educators' support for programs such as Museum Movement Techniques. My belief that Gardner and Davis's work with *Project Muse* (1996) foreshadows this philosophy prompted me to ask Harvard psychologist Howard Gardner to share his thoughts:

Of course, I am pleased by the AAM's acknowledgment that viewers are not all the same and that they can benefit from a variety of entry points, approaches, encounters. Also, the recognition of the encounter is important—objects do not speak for themselves, except to people who are experts, and so the way viewers interact with objects—initially and over time—deserves consideration. I don't think that it is necessary for curators and directors to become psychologists, but the more that they know about perception, ways of knowing, individual differences à la Gardner and Davis, developmental levels à la Housen-Yenawine, the better that they can serve a varied audience. Movement is certainly a viable point of entry for many individuals.

Movement as a viable way to learn in museums receives further endorsement from Philip Yenawine, museum education and an originator of Visual Thinking Strategies. "While I now stress verbal means of responding to art (VTS) and group interaction to stimulate a wide range of ideas," he told me, "I continue to think that using movement exercises can cement understandings of meaning—by which I mean situations, relationships suggested by works of art—and action and implied action within images."

Yenawine introduced the use of movement as an interpretive tool in the Arts Awareness Program at The Metropolitan Museum of Art in the early 1970s. Although he describes the children's connections to what they saw as "real and lasting," he shares that there were limitations. Interestingly, the concerns cited—educational value and ability to duplicate experience—are alleviated with Museum Movement Techniques' pedagogy.

Leading museum education authority and constructivist learning proponent George Hein believes that "constructivist experiences cannot be avoided. Individuals have an experience and make meaning out of the experience." With regard to the value of providing a variety of interpretive methods, Hein told me, "A variety of interpretive methods allow museum educators to reach more learners." When asked how he viewed movement as a tool to construct knowledge in museums, Hein pointed out that movement as a tool to learn "builds on a century of work on using the body to learn."

Conclusion: Next Steps

My personal journey to gain credibility for the use of movement as a method to learn in museums culminated in the pedagogy of Museum Movement Techniques. Further visitor research is recommended to continue to demonstrate the effectiveness of Museum Movement Techniques. This pedagogy described in this book offers a framework for educators.

Future pilot programs will expand the training of Museum Movement Techniques facilitators. The Primary Movement Facilitator Program will allow museum education professionals to develop kinesthetic skills for successful application of movement techniques and movement educational linking skills. In conjunction, the Adjunct Movement Facilitator Training Workshop will permit dance or movement professionals to develop an understanding of museum education philosophy, movement educational linking, as well as movement techniques. The Generalist Movement Facilitator Training Workshop will focus on the proficiency needs of school educators to integrate movement techniques and museum education dynamics to complement their educational curriculum.

An additional next step would be the creation of a professional organization of educators using movement to facilitate learning specifically in museums. This coalition would offer networking and resources to educators using movement to learn in art, history, children's, and science museums.

Museum Movement Techniques provide a powerful method of engaging the mind, body, and emotions of children in a dynamic process of learning and discovery of museum objects (figure 5.1). Most important, Museum Movement Techniques broadens the inclusion of the kinesthetic learners, thus increasing the audience base and supporting the goals of museum educators as well. Finally, I believe the blueprint for museum visitors' future is a process-oriented, content-specific, and constructivist-driven experience. Museum Movement Techniques provides the steps to take museum education to that next level of engagement and craft *moving* museum experiences.

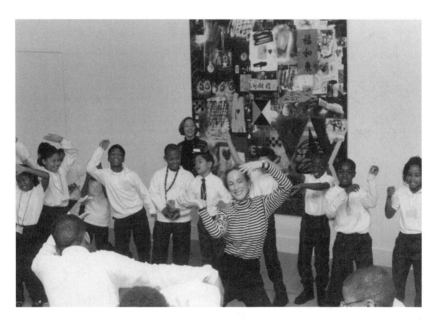

FIGURE 5.1 Museum Movement Techniques Experience at the Chrysler Museum of Art, Norfolk, VA (1999)

Museum Movement Techniques Workshop

A TYPICAL NINETY-MINUTE to two-hour workshop for new Museum Movement Techniques (MMT) facilitators follows this general format:

1. Presentation of supportive theories
2. Discussion of how techniques fit educators' needs
3. Demonstration of techniques
4. Explanation of educational links
5. Application of techniques by participants

The session begins with an overview of theories that validate the use of movement as a method for learning about museum objects is presented, including Gardner's theories of multiple intelligences, Piaget's developmental theories, Laban's movement education principles, Csikszentmihalyi's elements for optimal learning, and Dewey's educational philosophy.

Next follows an explanation of how the application of movement education theories to museum education culminates in the creation of Museum Movement Techniques and how the methodology fits into the

context of museum education. Care is taken to emphasize that Museum Movement Techniques serve museum education goals for museum objects and that specific movement techniques function as the methods that enhance understanding. The manner in which the techniques are delivered determines the success, making the nurturing of children's confidence and creativity paramount to the successful delivery of Museum Movement Techniques.

The experiential portion of the workshop follows (see figure A.1). Divided into two sections, the participants experience for themselves the techniques developed for their collection, first as children. This role play allows participants to recognize how movement is used as a tool to discover museum objects. This is followed by analysis of the process, which includes the techniques' educational objectives, museum object selection criteria, and ways to ensure the successful application of Museum Movement Techniques.

The second section of the experiential workshop allows participants to divide into groups and to apply techniques with a museum object. Using the nomenclature and museum object selection criteria, participants craft an experience and then share their application along with their educational linking with the group.

In closing, the participants are asked to give feedback by answering four questions about the workshop:

- Did the workshop meet your expectations?
- Have you improved your skills through your participation?
- Which aspect of the workshop did you find most helpful and why?
- Would you like to suggest any changes?

See appendix B for sample workshop feedback.

FIGURE A.1 MUSEUM MOVEMENT TECHNIQUES WORKSHEET

1. **Mirror**
 Museum Object Selection Criteria: Realistic or Animate
 Movement: Simulate
 Entry Point: Spatial
 Educational Link: Mathematics

2. **Alive**
 Museum Object Selection Criteria: Realistic or Animate
 Movement: Simulate + Activate
 Entry Point: Spatial + Expressive
 Educational Link: Mathematics + Language Arts/Science

3. **Map**
 Museum Object Selection Criteria: Abstract or Inanimate
 Movement: Simulate
 Entry Point: Spatial
 Educational Link: Mathematics

4. **Express**
 Museum Object Selection Criteria: Abstract or Inanimate
 Movement: Simulate + Activate
 Entry Point: Spatial + Expressive
 Educational Link: Mathematics + Language Arts/Science

5. **Composition**
 Museum Object Selection Criteria: Realistic or Animate & Abstract
 or Inanimate
 Movement: Simulate + Activate + Cooperate
 Entry Point: Spatial + Expressive + Social Cooperative
 Educational Link: Mathematics + Language Arts/Science + Social
 Science

Entry Points and Educational Links

Spatial Entry Point—The **spatial** quality of movement enhances
 understanding of mathematics.
Expressive Entry Point—The **expressive** quality of movement
 nurtures understanding of language arts and sciences.
Social Cooperative Entry Point—The **cooperative** quality of group
 movement promotes social sciences.

APPENDIX B

Museum Movement Techniques Workshop Feedback

NALYSIS OF workshop feedback from museum educators provides valuable insight into their comfort level and regard for Museum Movement Techniques (MMT) following workshops. This appendix presents information gathered from 135 evaluations collected from workshops at the McNay Art Museum, New Orleans Museum of Art, Mariner's Museum, Children's Museum of Richmond, and Science Museum of Virginia. Summary feedback responses are presented in table B.1.

The first question, "Did the workshop meet your expectations?" received an overwhelming yes response. Other frequent comments included "Didn't know what to expect" and "Exceeded expectations." Participants also noted, "More than met them. Had a wonderful ability of making people feel comfortable when it could have been real *threatening* situation," and "Very interesting approach to bringing meaning and creative expression to art. Workshop was most informative, makes me see things anew."

The second question, "Have you improved your skills through your participation?" also received an overwhelming affirmative answer. Additional

TABLE B.1 SUMMARY OF EVALUATION COMMENTS COLLATED FROM 135 MUSEUM DOCENTS AND EDUCATORS

Questions	Majority Comments	Frequent Comments	Other Comments
Did the workshop meet your expectations?	Yes	Exceeded Didn't know what to expect	Extent and relevance of material far greater than I imagined Shelley made me feel comfortable
Did the workshop improve your skills?	Yes	Helped me realize benefits Learned lots of creative ideas	Discovered I could move without embarrassment
What aspect of workshop was most helpful?	Explanation and demo of techniques Breaking into groups and applying techniques	Enthusiasm of presenter New way to involve children	Seeing Shelley interact with the children using MMT Feedback on applying techniques
Any changes to recommend?	No	Wished workshop were longer	Would like more info in advance, so as to know what to expect, i.e., preview MMT DVD

comments found prevalent were "Helped me realize benefits" and "Learned lots of great creative ideas." One interesting comment revealed, "Yes, I found I could move without embarrassment."

The third question was "Which aspect of the workshop did you find most helpful and why?" The typical majority responses were "Explanation of techniques, demonstration of techniques and then breaking into groups and doing [the techniques] ourselves"; "Enthusiasm and ingenuity of presentation"; and "New way to involve the children."

In response to the final question, "Would you like to suggest any changes?" the consensus was no. Additional prevalent comments included "Wish the workshop were longer"; others noted, "Would love to use this workshop to spark new ideas at museum" and "Wished I had more information about workshop in advance."

Based on the feedback from museum educators participating in an MMT workshop, it is clear that they appreciate the value and realize the benefits of Museum Movement Techniques. Participants' willingness to take part and their enjoyment in developing movement experiences for museum objects using movement techniques were evident. Most gratifying to learn is museum educators with no training in kinesthetic learning feel comfortable using Museum Techniques.

Museum Movement Survey

THE MUSEUM movement survey asked these four questions:

- What would you interpret movement or dance to mean in the context of museum education?
- Is movement or dance used in any capacity with your museum education programming? If so, how?
- Is movement used as a method of engaging children to learn about museum objects?
- What would be the level of interest in integrating movement as an interactive touring technique? Great—Mild—Slight

Results are summarized in table C.1.

Science Museums

Science museums interviewed include Science Museum of Boston; Field Museum of Natural History, Chicago; Science Museum of Minnesota; and Explorit Science Center in California.

FIGURE C.1 SUMMARY OF THE MUSEUM MOVEMENT SURVEY

Questions	Science	History	Art	Children's
1. What would you interpret movement to mean in context of museum education?	Spontaneous action	Unstructured improvisational	Method of conveying meaning	Exploratory way to learn
. . . dance?	Execution of actions	Series of steps	Performance art	Performance oriented
2. Is movement or dance used in any capacity with museum education programming? If so how?	Yes	Yes	Yes	Yes
. . . dance?	Performance art related to exhibit with interactive component	Performance art related to exhibit with interactive component	Performance art related to exhibit with interactive component	Performance art related to exhibit with interactive component

Questions	Science	History	Art	Children's
. . . movement?	Understanding of concept through movement	Movement interpretation of culture	Movement as form of nonverbal communication (drama) or understanding concept	Movement skill enhancement
3. Is movement used as method to learn about museum objects?	Yes	Yes	Yes	Yes
4. Interest in integrating movement as interactive tour technique?	Slight to Great	Mild to Great	Slight to Great	Great

In response to the first question, each museum generally interpreted the difference between movement and dance as the former being spontaneous actions and the latter being a designed execution of steps.

Question 2 provides insight to how movement and dance are utilized. The Science Museum of Boston incorporates degrees of movement within its Science Theater and Storytelling program. An example is having children do a certain movement task such as moving as slowly as they can. An example of integrating dance within programming was provided by the Field Museum of Natural History, which offer *dance* programs involving children in workshops focusing on museum exhibit content.

Question 3 reveals if movement is used as a method of engaging the children to learn about museum objects. Viewing movement as a means of engagement, the Field Museum of Natural History invites children to sense how large an object like the Dinosaur Sue might be by lining up. Children lie head to toe to form the vast size of Sue.

The Science Museum of Minnesota employs movement to enable children to learn how something works. In addition, movement learning opportunities exist in Science Museum of Minnesota's Summer Camps. The Science Museum of Minnesota is unique in that the staff recognizes that movement is not only a way to learn about exhibits but is also a great physical release of pent up energy for the children. A variety of movement learning activities led by trained dancers are integrated in camps that relate to their exhibits. For example, Camp Asaurus involves six- to nine-year-olds in movements illustrative of dinosaurs while in Roller Coaster Camp eight- to thirteen-year-olds experience the physical sensations associated with roller coasters.

Interestingly, the movement activities occur in an education classroom rather than in the galleries. Both the Field Museum of Natural History and the Science Museum of Minnesota expressed concern that children might harm the exhibit. Explorit Science Center engages motion to learn about objects. The educators there believe "learning involves engagement of all the senses and occurs best when people are using their cognitive skills, are engaged emotionally and/or affectively, and have physical or psychomotor involvement as well" (museum educator). An example occurs in the school visit introduction session on the Physics of Motion Exhibit. Children are asked to stand up and move in a variety of ways prior to viewing the exhibit. They list the different ways

they can move and then act them out as a group. Again movement occurs in a classroom setting, not in the exhibit area.

Question 4 probes the interest of educators in integrating movement as an interactive technique. Science Museum of Boston shared that previous attempts to involve children in creative drama sessions that used movement were highly successful with the children but not understood by the teachers who were unaware of the learning value of movement. It was also felt that the advent of standardized testing greatly diminished the prospects; in other words, the emphasis on standardized testing takes away from teacher's interest in creative modes of learning. Another drawback was felt to be the mature age of the volunteer docents and their resistance to change. The Field Museum of Natural History expressed mild interest in integration of movement touring techniques. It's interesting to note that although interest was described as mild, this educator asked numerous questions about what my program offers educators. The Science Museum of Minnesota was definitely interested, whereas Explorit failed to see benefits since there are no tours. Instead Explorit's visitors freely explore the exhibits and are not led by tour guides. Tour guides are posted at exhibits.

Answers revealed that the educators all felt programming could benefit from including movement techniques with children. Only one felt that although the idea poses many possibilities, it would not be a priority at her museum. The remainder of the science museums felt there existed potential to use movement with pre-K and kindergarteners to enhance their understanding of concepts related to exhibits.

The science museum interviews verify that movement is indeed being used as a tool to learn about museum objects. It appears that a limited amount of movement occurs in the galleries due to concern about controlling children's movement. Therefore, educators and facilitators need to be made aware of methods of movement control that enable children to experience movement in the galleries. Furthermore, the benefits of using movement need to be conveyed to volunteers and teachers as well in workshops in order to gain respect and acceptance. Although children may be toured through the museum by a volunteer facilitator, there also exists the situation of visitors moving at their will through the museum. The latter situation finds volunteer facilitators posted at exhibits. Since the posted facilitators have the potential to engage children in movement activities as they approach exhibits, training in

movement techniques would encourage the facilitators to do so. There is a consensus that programming would benefit from movement techniques to engage preschool children. Educators recognize the potential to teach preschool children concepts through movement. Children are kinetic and movement for them is a natural way to learn.

History Museums

History museums interviewed include Jamestown, North Carolina, Museum of Natural History; Winterthur Museum Garden and Library; and Experience Music Project in Seattle, Washington.

The educators surveyed described movement as unstructured, improvisational and expressive whereas dance is structured, a series of steps, related to music and usually choreographed.

Question 2 allows for understanding of how movement or dance is used. Jamestown offers a variety of educational programming incorporating both movement and dance. Dressing children up in period costumes and having them execute movements associated with colonial life such as milking cows exemplifies integration of movement. Teaching children period dances such as the minuet is an example of integration of dance in programming. North Carolina Museum of Natural History also employs both concepts. Movement is used to interpret the culture of the people who lived, worked, and influenced North Carolina as well as the natural habitat. Preschool children might engage in movement to bring to life an animal important to the natural history of North Carolina such as the beaver. Integration of dance is experienced with the learning of Scottish dances as part of North Carolina's history.

Winterthur involves children kinesthetically by having them act out nursery rhymes, pose like portraits, and learn about society through role-playing. Facilitators assign different roles to be played by children ranging from society ladies having afternoon tea to servants serving tea. Winterthur also uses dance to learn about society by instructing children in period dances such as a Maypole Dance.

Experience Music Project uses movement to explore music with a Eurhythmics specialist. Eurhythmics is a century-old method of music education that teaches all elements of music through physical motion. Movement workshop classes are developmentally designed

to integrate movement with their music exhibits. A movement workshop class uses movement and music to allow toddlers to experience jazz. No mention was made of efforts to teach period *dance* with period music. Rather movement was used to provide another dimension to understand rhythm, the product of their exhibits.

Question 3 addresses the use of movement to learn about museum objects. Clearly Jamestown, North Carolina Museum, and Wintethur use movement and dance to learn about their objects as illustrated by answers to question 2. Experience Music, a history museum of music, differs from the other museums in that its modality is sound. Responses indicate that Experience Music Project does not use movement to learn about museum exhibits and objects but rather as a different dimension to understand rhythm.

Question 4 asks educators about their interest in integrating movement techniques in touring. Jamestown is already on board. They believe interpretation is comprised of the emotional, intellectual, and physical experience, and that the fundamental principle is engagement. They validate the effectiveness of this method through extensive visitor research. Fourteen years of visitor research surveys verify that visitors want more interaction and more involvement. Jamestown views movement and dance as another tool in the toolbox. North Carolina Museum of History and Wintethur also expressed interest in movement techniques to teach children about museum objects. Experience Music Project educator described interest in integrating movement techniques as mild. It was felt that since the usual format does not consist of touring the children from exhibit to exhibit, it might be difficult to engage children.

Answers find that the museum educators all believe their programming could benefit from utilizing movement techniques with children. Jamestown constantly seeks new ways to involve visitors and regards movement as another modality. North Carolina Museum of History feels potential exists to employ *movement* with high school students. They believe in order to use movement with older students it is necessary to acquire skills to help high schoolers feel comfortable with *movement* activities. Wintethur wishes to see a greater use of period *dance* instruction integrated with their tours. Experience Music Project believes its programming can benefit but doesn't know enough about movement techniques to encourage learning about museum exhibits and objects.

Interestingly movement is used in three out of the four history museums in the same capacity. Perhaps this can be attributed to the fact that Jamestown, Wintethur, and North Carolina Museum of Natural History reflect historical periods whereas Experience Music Project traces the history of music. Jamestown, North Carolina Museum of Natural History, and Wintethur use movement as an interpretive modality to gain insight to the historical period represented by the museum, and dance instruction to teach authentic *dance* of the period. Experience Music Project uses movement taught by a dance educator to increase understanding of rhythm.

Regardless of the nature of the history museum, movement can be used to learn about museum objects and exhibits. More possibilities exist than are currently being employed. Movement technique selection criteria expose endless possibilities for movement engagement to promote learning. Again the nonexistence of guides touring a group through the museum should not be an issue in providing movement experiences. Just as in science museums, Experience Music Project volunteers posted through the museum have the potential to engage visitors in movement experiences as visitors approach their exhibit. Training in movement techniques designed to enhance and empower children to learn through movement allows volunteers to effectively facilitate with all age groups, even high school students.

Art Museums

Art museums that participated in the survey include Museum of Fine Arts Boston, Philadelphia Museum of Art, Museum of Modern Art in New York, and The J. Paul Getty in Los Angeles.

One educator felt the meaning of movement was defined as "one method of concretely conveying a meaning or concept. This can refer to a subject within a work of art or a concept within the concept." Another interpreted it as "acting out paintings. Moving in response to paintings or sculptures. Interpreting a work through dance or body language response" (Curator of Education). Educators utilized dance as a performance art to be thematically integrated in the context of museum education.

Question 2 reveals movement and dance are both being used in museum education programming. Movement application includes

docents using movement in a storytelling program that involves movement in the form of drama. Movement workshops for adults with special need audiences, although infrequent, were also cited. *Dance* application consists of performances with an interactive audience component.

In terms of using movement as a method to engage children to learn about museum objects, three of the educators shared specific ways movement is utilized. The use of movement in role-playing the artwork and enacting mythology stories are two general methods. Other specific examples include this story told by Marla Shoemaker of the Philadelphia Museum of Art:

> With K–2 we look for arches in our medieval cloister and then make a series of arches with our bodies, finding the shape in our heads, ears, fingers, fingernails, as well as making arches with our arms, legs, and whole bodies. The final challenge is for kids to make an arch big enough for a museum teacher to walk through. Two kids with arms together is the solution. Then we talk about 'London Bridge is Falling Down' and how the bridges are made of arches. The goal is for them to internalize the shape of the arch, which is such an important part of all medieval cloisters. With middle school aged kids, we compare two Indian Sculptures in our Temple Hall Madura, India. The sculptures are about ½ life size and are next to each other. One is supposed to represent an old holy man and one a young strong prince. We ask the kids to tell us which is which and then to tell us how they knew. In addition to some details, one of the differences is posture. Kids don't notice this until we ask them to sit (or stand if they are willing) with their backs in the position of each figure. This helps them notice that the old man's posture is erect but quiet, while the prince has his chest thrust out, back arched, up on his tip-toes. With high school kids, the only movement activity I can think of is when teaching our painting of *Prometheus Bound*, by Peter Paul Rubens. To reinforce the concept that diagonal lines in a painting make you feel movement, I ask some big guy to come up to the front of the class and stand with his feet together, sideways to the class, facing away from me. Then I ask him to fall back so that I can catch him, keeping his body stiff. Most times, the kids can't do it and put their foot

back to catch themselves because they are afraid of falling, but it makes the point either way that when human beings are on a diagonal they are moving . . . falling, running, whatever.

Question 4, with respect to interest in movement techniques, reveals a wide gamut of responses. One educator indicated mild interest, two other educators concurred with "of course interested in anything new," and there was "always room for change in methodology as long as there is staff consensus, age appropriateness and relevance to subject."

The final question concerning ways educational programming might benefit from movement techniques also finds different perspectives. Two educators expressed interest in regard to perfecting movement skills and as a way to keep those busy moving kinesthetic bodies focused. A third educator mentioned the potential of movement to broaden the audience base and the interest in interdisciplinary educational approach focused on the collection. The fourth educator, who utilizes movement presently, indicated that her museum uses it with the youngest audiences and occasionally the special needs groups but is not looking to expand at the present time.

Children's Museums

Children's Museums included in the survey are the Children's Museum of Boston, Exploris in Raleigh, Chicago Children's Museum, and Children's Museum of Seattle.

All four museums view movement as a way to learn that is inherent to children and acknowledge the power of physical engagement. Movement was defined as being exploratory and interpretative whereas dance was defined as performance oriented.

Question 2 reveals educators using movement in exhibits to refine motor skills. Two examples are a welcome song that involves children clapping their hands and moving their bodies and a climbing exhibit that challenges children to scale the wall. Just as with science museums, children's museums offer classes as part of a summer camp program or year-round workshops. These classes may focus totally around movement or simply use movement as a component. An example is a Mom

'n Tot movement class led by a movement or dance specialist to develop body awareness. Dance is used as performance art related to an exhibit's theme. For example, a dance group might perform a cultural dance and then invite audience participation.

Question 3 finds movement most definitely being used to learn about museum exhibits. Often movement is a component involved in making the exhibit work. For example, in Seattle Children's Museum's Cog City exhibit, children push and pull levers and learn reactions by making the parts move. Chicago Children's Museum's Body Odyssey exhibit involves children with a *bone boogie* to enhance understanding of skeletal/muscular systems.

There definitely exists interest in integrating movement techniques. Museums were generally interested in understanding ways movement could be used to teach about concepts related to museum exhibits. Additionally, there was interest in "any way to incorporate the five senses" (museum educator).

In terms of ways education programming might benefit from utilizing movement techniques, ideas ranged from integrating cultural dance to understanding concepts of exhibits through movement. An example of cultural dance integration would be teaching children movements associated with a Japanese fan dance to enhance the cultural experience of the Japanese House exhibit. Involving the children with their bodies to form shapes of a building exemplifies the use of movement to understand the relation of shapes with the Construction exhibit. Generally there was an overall interest in adding more movement learning to the museum experience. Questions again arose concerning how to make this happen in a nontouring situation. While leading children through the museum is an option, more often facilitators are posted at exhibits. Another concern was the time factor. These interviews reveal movement is part of the children's museum experience. The magnitude of movement's use may be fully realized with movement technique selection criteria, which promotes understanding of how and why to use movement with museum exhibits or objects. Again engaging children with a movement technique as they approach a volunteer's exhibit post presents an ideal way to ignite interest in the exhibit. The issue of not having much time promotes the initiation of movement techniques in an efficient manner.

MMT and Sample Educational Links

TABLE D.1 USING MMT TO FACILITATE UNDERSTANDING OF STANDARDS FOR MATHEMATICS

Technique	**Mirror**	Selection Criteria: Realistic/Animate
	Map	Selection Criteria: Abstract/Inanimate
Content Strands and Movement Task	**Number and number strands**	Students will simulate pose of an image in painting and discuss its left-to-right, right-to-left, top-to-bottom, bottom-to-top relation to other objects in painting.
	Measurement	Students will simulate two different poses of images in painting and compare length (shorter, longer), height (taller, shorter), weight (heavier, lighter), distance (far, near).
	Geometry	Students will simulate spatial properties of images in painting (circle, triangle, square, rectangle . . .) and explore the location of one object to another.
	Patterns	Students will simulate with their bodies similar images in painting according to size and shape.
	Functions	Students will simulate with their bodies repeating relationships of images in painting.

Source: Adapted from Mathematics Standards of Learning for Virginia Public Schools, Board of Education, Commonwealth of VA, October 2001.

TABLE D.2 USING MMT TO FACILITATE UNDERSTANDING OF LANGUAGE ARTS

Technique	**Alive**	Selection Criteria: Realistic/Animate
	Express	Selection Criteria: Abstract/Inanimate
Content Strands and Movement Task	**Oral Language Communication skills**	Students will communicate nonverbally through movement an expressive quality of museum object. Students will communicate verbally the meaning of their movement portrayal of the museum object.
	Reading	Students will interpret from right to left the museum object through movement and explain meaning of their movements as they thoughtfully relate to the museum object.
	Writing	Students will develop movement narrative for museum object integrating writing skill concepts, i.e., beginning, middle, and end of narrative.
		Students will expand their vocabulary by experiencing degrees of expressive qualities associated with museum object.

Source: Adapted from English Standards of Learning for Virginia Public Schools, Board of Education, Commonwealth of VA, November 2002.

TABLE D.3 USING MMT TO FACILITATE UNDERSTANDING OF STANDARDS FOR SCIENCE

Technique	**Alive**	Selection Criteria: Realistic/Animate
	Express	Selection Criteria: Abstract/Inanimate
Content Strands and Movement Task	**Scientific Investigation Reasoning and Logic**	Students will design movement narratives based on predictions gleaned from observations of museum object.
	Force Motion Energy	Students will design movement for museum object illustrating power, path, and degree of force based on observations.
	Matter	Students will simulate positions for museum object to demonstrate relations of over/under, in/out, above, below left/right.
	Life Processes	Students will design movement sequence to illustrate life cycles of museum object.
	Living Systems	Students will design movement sequence illustrating interrelationship between living and nonliving things depicted in museum object.
	Inter-relationships Earth/Space Systems	Students will design movement sequence illustrating growth cycles (animals, plants), and patterns of natural events (day/night, and seasonal changes) based on museum object.
	Earth Patterns, Cycles, and Changes	Students will design movement sequence illustrating patterns, cycles, and changes represented by museum object.

Source: Adapted from Science Standards of Learning for Virginia Public Schools, Board of Education, Commonwealth of VA, January 2003

TABLE D.4 Using MMT to Facilitate Understanding of Standards
for History and Social Sciences

| *Technique* | **Composition** | Selection Criteria: Realistic/Animate |
		Abstract/Inanimate
Content Strands and Movement Task	**History**	Students will work together to craft movement narrative illustrating sequence of events depicted in museum object.
	Geography	Students will work together to craft movement narrative illustrating relationships of people, places, or things represented in museum object with emphasis on near/far, above/below, left/right, and behind/in front.
	Economics	Students will work together to craft movement narrative illustrating relationships between natural resources (water, soil, wood), human resources (people working), and capital resources (machines, tools, and buildings).
	Civics	Students will assume different responsibilities and take turns
		Sharing in the crafting of movement narrative.

Source: Adapted from History and Social Science Standards of Learning for Virginia Public Schools, Board of Education, Commonwealth of VA, March 2001.

References

American Association of Museums (AAM). (1984). *Museums for a New Century*. Washington, DC: American Association of Museums.

———. (1998). *National Interpretation Project*. Washington, DC: American Association of Museums.

———. (2002). *Excellent in Practice: Museum Education Standards and Principles*. Developed by the Committee on Education. Washington, D.C.: American Associations of Museums.

Ansbacher, T. (1998). John Dewey's Experience and Education: Lessons for Museums. *Curator* 41(1): 36–49.

Arnheim, R. (1974). *Art and Visual Perception: The New Version*. Chicago, IL: University of Chicago.

Bartenieff, I., with D. Lewis. (1980). *Body Movement: Coping with the Environment*. New York: Gordon & Breach Science Publishers.

Bernstein, P. (1972). *Theory and Methods in Dance-Movement Therapy*. Dubuque, IA: Kendall/Hunt.

Blythe, T., with D. Perkins. (1998). Teaching for Understanding Framework (pp. 17–24). Understanding Understanding (pp. 9–16). Ongoing Assessment (pp. 71–88). In T. Blythe and the Researchers and Teachers for Understanding Project, *The Teaching for Understanding Guide*. San Francisco, CA: Jossey-Bass.

Bonbright, J., and R. Faber, eds. (2004). *Research Priorities for Dance Education: A Report to the Nation.* Bethesda, MD: National Dance Education Organization.

Brown, M. E., and N. Precious. (1968). *The Integrated Day in the Primary School.* New York: Agathon.

Broudy, H. S. (1987). *The Role of Imagery in Learning.* Los Angeles, CA: J. Paul Getty Trust.

Chalmers, F. G. (1996). *Celebrating Pluralism: Art, Education, and Cultural Diversity.* Santa Monica, CA: J. Paul Getty Trust.

Children and Their Primary Schools. (1967). Department of Education and Science, Vol. 1. London: Her Majesty's Stationery Office.

Cole, P. R. (1998). More on Dewey: Thoughts on Ted Ansbacher's Paradigm. *Curator* 41(2): 78–80.

Coles, R. (1992). Whose Museums? *American Art* (Winter): 11–16.

Csikszentmihalyi, M. (1991). *Flow: The Psychology of Optimal Experience.* New York: HarperPerennial.

Csikszentmihalyi, M., and K. Hermanson. (1995). Intrinsic Motivation in Museums: What Makes Visitors Want to Learn? *Museum News* (May/June) 74(3): 34–37, 59–62.

Cunningham, M. K. (2004). *The Interpreters Training Manual for Museums.* Washington, DC: American Association of Museums.

Davis, J. (1996). *The Muse Book.* Cambridge, MA: President and Fellows of Harvard College.

Davis, J., and H. Gardner. (1993). Open Windows Open Doors. *Museum News* (January/February): 34–37, 57–58.

Deasy, Richard, ed. (2002). *Critical Links: Learning in the Arts and Student Academic and Social Development.* Washington, DC: Arts Education Partnership.

Desmond, J., ed. (1997). *Meaning in Motion.* Durham, NC: Duke University Press.

Dewey, J. (1934). *Art as Experience.* New York: Perigee.

———. (1949). *Experience and Education.* New York: Macmillan.

Dobbs, S. M. (1992). *The DBAE Handbook: An Overview of Discipline-based Art Education.* Santa Monica, CA: J. Paul Getty Trust.

———. (1997). *Learning in and through Art: A Guide to Disciplined-based Art Education.* Santa Monica, CA: J. Paul Getty Trust.

Egenberger, C., and P. Yenawine. (1999). *As Theory Becomes Practice: The Happy Tale of a School/Museum Partnership.* http://vue.org.

Eisner, E. W. (1988). *The Role of Disciplined-based Art Education in America's Schools.* Los Angeles, CA: J. Paul Getty Trust.

Ely, M., with M. Anzul, T. Friedman, D. Garner, and A. Steinmentz. (1991). *Doing Qualitative Research: Circles within Circles.* New York: Falmers.

Eversmann, P. K., R. T. Krill, E. Michael, B. A. Twiss-Garrity, and T. R. Beck. (1997). Material Culture as Text: Review and Reform of the Literacy Model for Interpretation, pp. 135–167. In A. S. Martin and J. R. Garrison, eds., *American Material Culture: The Shape of the Field.* Winterthur, DE: Henry Francis Du Pont Wintethur Museum.

Falk, J. H., and Dierking L. D. (1995). *Public Institutions for Personal Learning. Establishing A Research Agenda.* Washington, DC: American Association of Museums.

———. (2000). *Learning from Museums: Visitor Experiences and the Making of Meaning.* New York: AltaMira.

Ferren, B. (1997). The Future of Museums: Asking the Right Questions. *Journal of Museum Education* 22(1): 3–7.

Fiske, E. B. (2000). *Champions of Change.* Washington, DC: Arts Education Partnership & President's Committee on the Arts and Humanities.

Fried, J., F. Levy, and F. Leventhal. (1995). *Dance and Expressive Art Therapies: When Words Are Not Enough.* New York/London: Routledge.

Gardner, H. (1982). *Art, Mind and Brain: A Cognitive Approach to Creativity.* New York: Basic Books.

———. (1983). *Frames of Mind: The Theory of Multiple Intelligences.* New York: Basic Books.

———. (1990). *Art Education and Human Development.* Santa Monica, CA: J. Paul Getty Trust.

———. (1991). *The Unschooled Mind: How Children Think and How Schools Should Teach.* New York: Basic Books.

———. (1993). *Creating Minds.* New York: Basic Books.

———. (1999). *Intelligence Reframed.* New York: Basic Books.

Gartenhaus, A. (1993). *Minds in Motion.* San Francisco, CA: Caddo Gap.

Goodrich Andrade, H. (2000). Using Rubrics to Promote Thinking and Learning. *Educational Leadership* 57(5): 13–18.

Newsome, B. Y., and A. Z. Silver, eds. (1978). *The Art Museum as Educator.* Berkeley: University of California Press.

North, Marion. (1973). *Movement and Dance Education.* Plythmouth, UK: Northcote House.

O'Neil, S. (1996). *The MUSE Guide.* Cambridge, MA: Harvard Project Zero.

Parsons, M. J. (1991). Cognition as Interpretation in Art Education. In B. Reimer and R. A. Smith, eds., *The Arts, Education and Aesthetic Knowing. Ninety-first Yearbook of the National Society for the Study of Education, Part 2.* Chicago, IL: University of Chicago Press.

Penrose, William O. (1979). *A Primer on Piaget.* Bloomington, IL: Phi Delta Kappa Educational Foundation.

Perkins, D. (1986). Thinking Frames. *Educational Leadership* 43(8), 4–10.

———. (1988). Art as an Occasion of Intelligence. *Educational Leadership* 45(4): 36–43.

———. (1994). *The Intelligent Eye: Learning to Think by Looking at Art.* Los Angeles, CA: J. Paul Getty Trust.

———. (1998). What Is Understanding? In M. S. Wiske, ed., *Teaching for Understanding: Linking Research with Practice* (pp. 39–57). San Francisco, CA: Jossey-Bass.

Perkins, D., and C. Unger. (1999). Teaching and Learning for Understanding. *Instructional-Design Theories and Models*, Vol. II. (pp. 91–113). New Jersey: Lawrence Erlbaum.

Piaget, J. (1973). *The Child and Reality.* New York: Grossman Publishers.

Pitman, Bonnie. (1999). *Presence of Mind: Museums and the Spirit of Learning.* Washington, DC: American Association of Museums.

Portnoy, J. (1970). Dance and the Other Arts. In M. H. Nadel and C. G., eds. *The Dance Experience: Readings in Dance Appreciation.* New York: Praeger.

Rhyne, Jamie. (1996). *The Gestalt Art Experience: Patterns That Connect.* Chicago, IL: Magnolia Street.

Roberts, Lisa. (1997). *From Knowledge to Narrative: Educators and the Changing Museum.* Washington, DC: Smithsonian Institution Press.

Seidel, S. J. Walters, E. Kirby, N. Olff, K. Powell, and S. Veenema. (1997). *Portfolio Practices: Thinking through the Assessment of Children's Work.* Washington, DC: National Education Association.

Silverman, L. (1991). Tearing Down Walls. *Museum News* (November/ December) 70(6): 62–64.

———. 1995. Visitors Meaning-Making in Museums for a New Age, *Curator* 8(3): 161–70.

Silverman, Lois H., and Mark O'Neill. (2004). "Change and Complexity in the 21st-Century Museum." *Museum News* (November/December) 83(6): 37–43.

Spitz, A. and Associates, eds. (2000). *Learning and the Arts: Crossing Boundaries.* Chicago, IL: Amdur Spitz and Associates.

Thomas, H. (1995). *Dance, Modernity and Culture.* New York: Routledge.

Vygotsky, L. S. (1978). *Mind in Society.* Cambridge, MA: Harvard University Press.

Walsh, A., ed. (1991). *Insights: Museums, Visitors, Attitudes, Expectations. A Focus Group Experiment.* Santa Monica: J. Paul Getty Trust.

Weil, S. (1990). *Rethinking the Museum and Other Meditations.* Washington, DC: Smithsonian Institution Press.

Weisberg, S., E. Becker, D. Goldstein, and B. Walker. (1978). Expressive Therapies: Administrative Considerations. *American Journal of Art Therapy* (July).

Weisberg, S., and A. Vernon. (1998). Art Is a Moving Experience. *The Docent Educator* (Fall).

Weisberg, S. (2003). A Moving Museum Experience. *Virginia Association of Museums* (Spring).

———. (2003). A Moving Museum Experience for the Gifted and Talented, *Gifted Education Quarterly.*

———. (2004). A Moving Museum Experience. *Museum Education Roundatable.* www.mer-online.org.

———. (2004). Reaching Out to Underserved Children. *Illinois Association for Gifted Children* (Winter).

Whitman, G. (2004). *Dialogue with the Past: Engaging Students and Meeting Standards through Oral History.* Walnut Creek, CA: AltaMira Press.

Winner, E., ed. (1991). *Arts PROPEL: An Introductory Handbook.* Cambridge, MA: President and Fellows of Harvard College.

Winner, E., and L. Hetland. (2000). The Arts and Academic Improvement: What the Evidence Shows. *Journal of Aesthetic Education* 34(3–4) (Fall/Winter).

Wirth, A. G. (1979). *John Dewey As Educator.* New York: Kreieger.

Wittlin, A. S. (1949). The Museum, Its History and Its Tasks in Education. London: Routledge & Kegan Paul.

Wolf, D. (1988/1989). Opening Up Assessment: Ideas from the Arts. *Educational Leadership* 45(40): 24–29

Yenawine, Phillip. (1998). "Visual Art and Student-Centered Discussions," originally published in *Theory into Practice* (Autumn 1998). http://vue.org.

———. (1991). *How To Look At Modern Art*. New York: Abrams.

———. (1999). *Theory into Practice: The Visual Thinking Strategiese*. http://vue.org.

Index

About the Author

SHELLEY KRUGER WEISBERG received her M.Ed. from Lesley University in Cambridge, Massachusetts, where she synthesized her knowledge of kinesthetic learning and education, garnered in her career as a dance educator and movement therapist, to propose a novel approach to learning in museums. As part of her graduate work Weisberg conducted a qualitative study "Movement as a Catalyst for Learning in Museums." Current work includes designing MMT workshops to enhance museum educator's objectives and presenting national and international conferences.